The Yesterday, Today, and Tomorrow Project:

Yesterday

Compiled and edited by Julianna Warner

Text copyright © 2013 by Julianna Warner
Cover Illustration copyright © by Conner Berkey

All rights reserved. Printed in the United States of America. No part of this book may be reproduced in any form or by any means, electronic or mechanical, including photocopying, recording, or by any information storage and retrieval systems, without written permission of the publisher or author, except where permitted by law.

Published by
Julianna Warner

Third Edition

The Yesterday, Today, and Tomorrow Project: Yesterday/ compiled and edited by Julianna Warner; illustration by Conner Berkey; back cover photo by Alicia Carman

ISBN: 978-1482323054

Contents

Part One
Janice D'souza...3
Benjamin Timby...5
JeniSage Sidwell...10
Maggie Hess..13
Luis Fernando Mora...16
Shaina Finney..21
Heather Dent...25
Husam Nasser...28
Julia Collins...34
Lucas Warner..36
C. Brobeck..39
Damya Reine...41
Monica Leslie..46
Anonymous...51
Lewis Kilongo..52
Marisela Rodriguez Gutiérrez...55
Anonymous...60

Part Two
John Warner..73
Jose V. Pimienta Bey..79
David "Boots" Humphrey...92
Denice Reese..102
Nancy Gift...108
Dave Porter...113
Caroline Barbara Carr-Starr..116
Bill King...122
Dusk Weaver...131
Kate Long..138
Randall Roberts...141
Fred de Rosset..145
Tripp Bratton...152
Anonymous...164
Bob and Carolyn Jones..170
Kathryn Akural...171

Acknowledgements

I would like to express my gratitude to the many people who have supported me and my project; to all who have offered suggestions, helped me proofread, and encouraged me, thank you. Specifically, I would like to thank my parents, Denice Reese and John Warner, and Scott Kenney for assisting me in the process of proofreading and editing, as well as Jane Edwards Mecham for helping me design and print beautiful CDs with audio clips from the interviews. A special thanks to Courtney Streets, Ruth Rogers, Melissa Brown, Jeff Fetty, Kate Egerton, Darrian Rapp, Eleanor Nestor, Jason Cohen, Beth King, Susan Krakoff, Ashley Warner, Lori DiBacco, Robin Finney, William Shaw, Madeline Beath, Mary Kibler, Dinorah Marquez, Raoul Deal, April Daras, Jorge Luis Hernández Oliva, and Victor Thacker. Your support and encouragement have further fueled my passion for this project.

Editor's Note

The following stories are written submissions as well as transcribed interviews. While all of the people whose interviews were recorded were given the opportunity to "clean up" their off-the-cuff responses (and some did), many preferred to leave their stories in their original raw form – sentence fragments and all. During the editing process, my main goal was to eliminate distractions while preserving each subject's voice.

Part One

Tell me about something you know now that you wish you had known in middle or high school. Or, write about some aspect of that time in your life that resulted in unexpected growth, that you did not think would affect you positively.

❀ ❀ ❀

Janice D'souza *is from the city of Mangalore, India. Her parents were separated when she was ten. She was sent to boarding school in a different state, where girls were mean and she learned to guard her heart and her candy. Until the age of 14, she lived in different boarding schools, but came back home, only to find herself living alone again in an apartment. Her mother had gone to Israel to work as a caretaker, and her father lived in Dubai with his wife. She lived in her mother's apartment when she was 16 and learned what it really is to be alone and to be mostly okay with it. She also learned how to be an Indian Spartan woman and protect herself.*
Submitted in written form.

I struggle to find words to capture the loneliness, intensity and heartbreak of that one year. Even though I have lived alone since then, 2007 was not a good year. In India, after tenth grade is college. It is called Pre University and is divided into three categories: Science, where all the 'smart' students go to become doctors and engineers; Commerce, a choice for the

mediocre students who wanted to be accountants or bankers; Arts, for students who wanted a degree to get married. These students studied topics such as History, Sociology, and Psychology, topics not valued in the Indian education system. I loved History, Economics, and Psychology. I walked into my first class and found out that I was one of the few students who spoke English.

In the first month, I made some friends – not many, but enough to eat lunch with someone. Come October, my mother had left home to go to Israel to work as a caretaker. I then found myself living alone. Initially, I enjoyed it. The freedom was wonderful and I could sleep whenever I wanted. But slowly, things got worse. My classmates stopped talking to me because divorce was a stigma and parents did not want their children to be associated with someone who lived alone. My neighbors stopped talking to me because my then-boyfriend would come home once a week to give me company. I did not know how to cook, so I chewed ice and drank about 30 cups of coffee a day. I slept on the floor as my mother had locked the room with the bed in it. I weighed about 80 pounds and had eyes that looked like craters in the moon. Men knocked on my door at night assuming I was a prostitute. All in all, 2007 was a shithole.

In all those awful times, I walked into my apartment craving to hear some kind of familiar voice or to have a hot meal

prepared, or wondering where my mother was (she did not tell me where she had gone). What did I wish I had known? I wish I had known my own strength. When I had no friends in school, and I spent all my evenings either rereading books at the library or spending my time at the senior home, I wish I had known my strength was limitless. I wish I had known this experience would make me strong for years to come when I would study in the United States and spend all my holidays and breaks at the homes of strangers, or when I would spend a summer in Boston and could not cook and knew no one in the city – I could manage because I have survived worse. I wish the 16 year old Janice would have known all that loneliness would pay off, because she can now spend hours with herself and not crave for company or attention. I wish she knew that life does not get better, but you sure do. I wish she knew she would be in the United States, and that one awful year would be the basis of her college essay. I wish I could tell her not to stop believing in herself, because that belief will be the only thing going for her for the years to come.

*In carrying out a four-thousand mile bicycle trek to Alaska following high school graduation, **Benjamin Timby** discovered his appreciation for spirituality and the tools of religion in*

seeking a deeper and more genuine change in the world. Travelling to monasteries around the country has furthered Ben's purpose in seeking to relate these tools of ancient spiritual traditions with modern challenges. Coupling faith with action, Ben has worked on bicycle machines with indigenous Guatemalans, planned and implemented a fruit orchard at an orphanage in Mexico, and initiated relationships and support with the international community at his college in Berea, Kentucky.

Submitted in written form.

Wheels of Change: Seeking a Deeper Change in the World

My father and mother both came from broken families of alcoholism, multiple divorces, and abandonment. My dad was hopping freight trains at seventeen while my mom was taking care of her four younger siblings on the opposite side of the country. In their twenties, they were brought together by a mutual discovery of the Christian faith. Through this faith, both encountered an incredible sense of peace, community, and spiritual renewal from the cold in which their families had left them. In searching deeper into their faith by exploring the Eastern Orthodox Church of Greece and Russia, the Coptic church of Egypt, the Ethiopian church, and many other Christian traditions rooted in Africa, the Middle East, and Asia,

they encountered a side of Christianity they had never encountered before. At four years old, I was baptized into the Eastern Orthodox Church of Antioch, along with the rest of my family, in what many of my extended family members still consider one of the strangest choices our family ever made.

If I myself had been an adult at the time of my family's conversion, I probably would have shared the same opinion. But growing up in the mystical traditions of the ancient church of the East captivated me – I couldn't have asked for a life any different. Growing up alongside Russians, Greeks, and Ethiopians singing and chanting thousand year old prayers, surrounded by mosaics of icons, taking in auras of candlelight and incense proved such an enrapturing form of prayer for my young soul. Surrounding me in prayer, song, and sermon were teachings of wisdom, humility, and love – teachings which had passed on through the experience of the saints even to this present day. I have memories, true or imagined – I cannot tell – of entire churches glowing with energy. I swear in those times I knew that a God existed, and I could feel His presence.

When I was ten years old, our family moved across the country. As the years went on and I gradually entered my teenage years, my attention and energy began shifting into fitting "the mold" of my peers in middle and high school. In establishing my new identity, I distanced myself from my family and their religion and sank into heavy alcohol and drug

use. The years that followed seem like a blur, a period of numbness in my life. It wasn't until I made friends with a group of political activists while wandering into a non-profit bicycle collective in my hometown at age seventeen that I really felt like my spirit re-awakened. Suddenly, I was surrounded by people outside the drugs, the vanity, and the selfishness in which I had immersed myself – people who were truly zealous for life and love and change in this world. Rafael, an undocumented Mexican immigrant and founder of the "Bike Against Coop", took me under his wing, and I spent my senior year of high school living, eating, and sleeping beside my new-found brethren, learning the mechanics of one of the world's most incredible tools for social, political, and spiritual change: the bicycle. We ran an open, free-of-charge community shop in which we taught people how to fix bicycles and provided all the tools and parts to do it. While I still maintained a distance from any form of faith or religion at the time, these experiences of genuineness and goodness were a catalyst for what would become my full-circle journey back to belief in something greater.

With high school coming to a close, I decided that I had no interest in following my peers to college and began hatching an escape plan from society. Days after my graduation, I set off on a four thousand-mile bicycle trip to Alaska. It's impossible for me to describe how life-changing that decision was. The

experiences, the beauty, the generosity and kindness of so many strangers and friends along the way overwhelmed me and gave me such a deep appreciation for the world and the goodness found in it. Along the way, I would stop for a day or two and head into the wilderness of the Canadian Rocky Mountains. Being there, thousands of miles from everything, I encountered the Divine. I vividly remember lying beneath the stars one night in the Yukon, staring at the Milky Way. The culmination of beauty I felt in that moment overwhelmed me – I could feel my soul burning as it had when I was a child. Needless to say, by the trip's end, I emerged from the wilderness a believer in a Higher Power.

In the years following that trip, I have dedicated my life to pursuing the Divine, God, Goodness with all my heart, in whatever form it might exist. While I have wrestled with much of the theological and philosophical rhetoric surrounding God and the Divine in this quest, I am grateful for the experience and wisdom of all who have come before us, and consider myself blessed to remain open to the poetry of our past in exploring our deeper purpose in this world. It is my hope to spend the rest of my life seeking and growing in this wisdom.

JeniSage Sidwell *is a 21-year-old college dropout from Salt Lake City, Utah. She is currently living in Berea, Kentucky and working as a film editor. Her favorite color is turquoise, she can beatbox, she plays the harp, and she has three pets presently scattered around the United States. Maybe one day they will all be reunited.*

Submitted in written form.

I attended high school at Logan High in Logan, Utah. I was an active Mormon at the time. My greatest fear was (and still is) disappointing those I love, and the Church (in Utah, "the Church" is always used in reference to the Mormon Church) placed a great amount of pressure on its members, particularly the youth (teenage years are an excellent time to rebel). This took a great toll on my schoolwork and search for my identity. I was also burdened with severe depression throughout middle school and high school, and was placed on over ten different medications throughout. Ten medications on a kid! Believe it. It's wacky to think, in these modern days, how willingly we will play slot machine with a child or adolescent's brain. Kids are being placed on meds as routinely as the previous generation got their tonsils removed (according to Sir Ken Robinson).

Anyway, near the end of my senior year, the doctor told me to put a new antidepressant in my body that would kill me if I took Sudafed, or ate anything that contained too much

tyramine (that meant no cheese or soy sauce). My faith in the Church was also slowly disintegrating, which caused a cataclysmic turn of events that marked the beginning of a great paradigm shift. During the last month of school, I stayed home and cried every day. My parents had to bring my homework to me. I almost didn't graduate, but the counselor took a liking to me. I had wanted so badly to begin my adult life and start fresh, and the closer I got to deliverance, the worse the problem seemed to become.

Evidently, masking the problem with medication did not work to my benefit, and I was dumped into independent life knowing almost nothing about myself. A year or two after high school, I stopped taking pills and started learning about how my brain worked. Reader, this was one of the best decisions I've ever made. Instead of artificially balancing my chemicals, I was learning coping strategies that worked best for me. I had never been given the opportunity to wake myself up to what was inside of me. At age 18, I left the Mormon Church and played the wacky game of life according to my own rules (while still upholding some of the pulchritudinous lessons I learned whilst I was involved with the Church).

Were I given the option to go back to that time knowing what I know now, I would never do it, considering the bounty of awesome lessons I learned. Middle school and high school is the best time for people to err and start figuring themselves

out, and I am a paragon of this. I'm glad I got a taste of the nasty world so that now I can better enjoy the wonderful one. Because all this zany shit happened, I live now in a state of constant and total awe.

However, if I could, I would take the opportunity to offer myself some words of advice. I'll narrow it down to a few.

<u>My advice to me</u>:
- Take time to reflect on how far you've come. Seriously, don't forget this.
- Life is short, but it's long enough to get everything done that you desperately want to do. Slow down.
- Don't take yourself so seriously. No one else does.
- Have an awesome fucking cry every now and then.
- Listen to your body. It runs on instinct.
- Don't be intimidated by something you don't know. Learn it.
- There's no secret for happiness. It's relative, and we all have it in us. Make some mistakes and get depressed; it's the only way to narrow it down. It will really truly come much sooner than you think.
- LOVE. EVERYONE.
- If the weather's good, take advantage of it and don't waste time. **Carpe the SHIT out of that diem.**
- Remember that lots of people love you and think you're really boss.

- You have to play the game until you're out of high school, and then things start to improve drastically. Don't listen to the people who say these are the "golden years." They are not.
- Nature is A+. Go be in it. Your body will thank you.
- Smiling feels great. Do it more.
- Everyone is capable of so much good and that is just so great.
- Don't just balance work and play. Balance work, play, and creativity. For crying out loud, live beautifully.
- Life really doesn't have to be as goddamn serious as it seems.

(By no means am I trying to campaign that antidepressants are a bad idea. I am probably the kind of person who shouldn't have been put on so many, but I realize that a lot of people are very successful on medication. This story only reflects the actions that worked to my benefit.)

Maggie Hess is a recent Berea College graduate from Bristol, Tennessee. She is a poet, writer, artist, and painter. Maggie recently had success on Kickstarter.com where she collected funds for a calendar-making project. She loves nature and hopes

the peoples of this earth slow down climate change before we all are sunk! Remember her wisdom.
Submitted in written form.

I wish I had known...

I believe in the truth. I believe in speaking the truth at all times. I am not always perfect at this. Sometimes my own ignorance leads to my lies, but at other times it is my fear of consequences or hurting the feelings of others. But I am dedicated to truth telling, to soothsaying, to honest expression. That is why I write and hold writing as the first and primary emblem of my personality.

It wasn't always this way. When I hit junior high school, I have a memory of getting more social invites than I could happily stomach. Like every subject, I talked over my overbookings for sleepovers and cookie bakes with my father. The essence of his response was that I should just tell the other teens that I didn't want to go to their house and watch Saturday Night Live or go skating.

But truth is not a pre-sliced pie of black and white with easy segments and categories. As I distanced myself from certain "best friends", I found myself settling for a girl named Tequila.

Today I often regret our friendship. I think Tequila and I were codependent. For a long time, we were inseparable,

which felt wrong for me, as though the nature of our friendship went against the gestalt nature of my person.

I remember the bad. I remember how she pressured me to sneak out of my house with her at night on two occasions to spend time with boys who, our parents agreed, were particularly bad influences. I remember Tequila, the babysitter of a CHILD, and me there, too, abetting and as guilty as Tequila as she liberally sampled the liquor cabinet. (And I took sips.) I remember Tequila was wild. Looking back, I realize she was having mental health issues. But what I remember is Tequila inviting me over to her home so many nights, her parents' homophobic words, and our naked closeness.

I remember the morning after the closest night, Tequila fleeing to the bathroom, showering angrily, me ashamed.

Today, Tequila and I do not speak. We used to keep up with each other occasionally by phone. The last time she and I visited, I saw her baby when her husband was at work.

He was the one who wrote the email on Facebook cutting Tequila out of my life forever. I never met that man. In the email, he mentioned that I was too political in my posts. It was a few years ago. I had written something for tolerance, for compassion, for marriage for all people.

I always was honest. Even when things were shitty. I know that sitting here crying, as I dredge junior high and high school out of my memory.

It was worth it to be friends with Tequila – and not just for the practical reason of not ever falling into the pit of alcohol myself – because I watched it steal her childhood. Tequila was worth it because I chose Tequila then, because I wrapped my arms around hers, because we swam together each summer, because she was my friend.

❁ ❊ ❀

***Luis Fernando Mora** was born in 1990 in Yahualica, Jalisco, Mexico. He moved to Milwaukee, Wisconsin when he was 4 and has lived there ever since. He likes to people-watch and to notice the little things that make people unique. He likes to draw people while they are sitting. He enjoys befriending a lot of women, and he thinks it is great to learn from the female mind and the natural motherly charisma they have. Learning from women has always been a huge part of his life. He loves science fiction, art, reading journals and first person narratives, trying out different cultures, and reflecting back on his own to learn cultural lessons. Taped interview. January 4, 2013.*

I spoke Spanish, but I wasn't necessarily proud of who I was as being from out of the country. Seeing how my parents, and myself, are still in a non-status in the U.S., not even residents or anything, or citizens, or on any sort of path – it was kind of, not

shameful, but hard to need to talk about that, or just that fact that I would hear my parents all the time speak about how hopeful they would be that there would be some sort of amnesty that would help – that it was just difficult for me to realize that I am different because the struggle is different when you're growing up and you're in the shadows, you know? So, I definitely wasn't as proud to be Latino and to be from another country, just because the conservativeness of some folks can be so alienating to try to connect with them, or try to be a part of them, instead of being a part of my own people, or not just being stuck with my own people, but seeing if I can also speak out my mind and maybe try to change what they think in the right way. So, I definitely wish that I had been told a lot earlier that it's cool to be different, or not just cool, but it's a part of me, and I'm not alone.

When I came to the U.S., I went to St. Anthony's school, which was located on the south side of Milwaukee. It was mainly a lot of Latinos. By '97 or '98 the school had been mainly Latinos from being a Catholic private school. There were more white folks during the '80s. In the '90s, the Latino population started to rise in Milwaukee and a lot more students were going. I grew up with a lot of Latinos in my class. It was cool to have all of us, or a lot of us, be first generation immigrants to the U.S. and to have all this common-ness like that among other people.

In 6th grade, the school got so big that they were going to have two campuses and the principal wasn't ready to merge with that because the archdiocese in Milwaukee wanted to become part of that, too, and help. The principal had helped me and my parents a lot when we were younger, coming here and being on the Choice Program, which helps a lot of immigrant students, or people who are low-income families, obtain private schooling for grade school and high school, which I think is amazing. So, he switched to another grade school that already had two campuses, but they had already gone through the change three years before and they had already settled down. He was a good guy, so what he embedded into the school really helped a lot of Latino parents stay connected to actually having their children have an education. And a lot of positiveness has come out of him being a principal and being very strict and not having the school be involved in drugs and other fallout for children.

So, I left to this other grade school and I became aware of my sexual identity almost, to a certain point. Now that I had left my other school – at St. Anthony's, I had a lot of guy friends growing up. Not that I was rough or anything. I played sports, but I was kind of soft, too. I liked to hang around more with the jokesters and people who, I don't know, were just, like, cracking jokes in class and just having fun. That was nice. Then, when I went to Holy Wisdom Academy, I was kind of quiet. It

was a totally different change from – it was seventh grade that I was entering a new school, and that was pretty interesting. I mean, everybody had already formed their groups and their opinions on one another, and me having to merge into that and be a teenager at that point. That was pretty interesting to me. But, I started to notice my sexuality and the way that I was really noticing that guys just liked to play sports and that I was hanging around with the nerdy people.

In 8th grade, I became friends with a lot more girls, and a lot of the popular girls, and girls who were really nice to me, and might have known in middle school that I was gay, but respected me. And it was cool to be in the Catholic private school and to have also the jocks and the other kids to have a respect level towards me. And then, I was able to fully want to just be friends with girls just because it's easier to communicate with them. It's not like I find myself being a female, but I can almost relate to a certain point, being vulnerable and growing up being gay, and – I don't know. It's hard to explain. I'm not sure what I'm saying.

Just knowing the fact that women can be there for you. Because, I mean, every – not every girl – but every girl wants to be a mother, and it's that caring compassionate part that is kind of nice, that if you listen to them and be their friend, they can give back and what-not. And you're growing together with them. And girls also want to hang out with guys. I didn't realize

that it was going to influence me in becoming friends with – or choosing my friends wisely, and knowing how to keep my mind to myself, 'cause that's what a lot of girls do. I'm not a female, but I do know that females can be pretty competitive with each other, to a certain point. And I didn't realize that I was being taught that. But now I do. And I really like that I've been able to keep to myself and watch my distance from others and be self-aware of who I am and know that I'm different.

What would you tell yourself (or to someone in a similar situation as you were at that point) if you could go back in time to your middle or high school years?

I feel like I would definitely tell myself that there are people out there who are different, and you don't have to be a part of something to feel accepted and that being different can be totally okay, and that there will always be people around me, because if I were to keep my caring nature, not feel lonely, and not feel exasperated from trying to find my own identity and my base with myself – patience, maybe. Patience, and just to obtain as much knowledge from the good of what's trying to benefit me.

Shaina Finney *is currently a senior undergraduate at Berea College, studying English, Spanish, and Latin. She grew up in Villa Rica and Jonesboro, Georgia. Before coming to college, she was taught at home from pre-school through her senior year of high school. This writing focuses on a time in her education which could have ended in the abandonment of her studies, but instead served as the opportunity to revitalize them.*
Submitted in written form.

Finding Structure in the Embrace of Chaos: The High School Years of an Autodidact

Unconventional from the beginning, unusual at its best, my education has taken many twists and turns along the way. From pre-school to sixth grade, I was taught through a strictly Christian home-school curriculum published through Pensacola Christian College. From seventh to ninth grade, I was part of an online academy of homeschooling families from around the world. My classmates were everything from missionary kids to military brats to rebels kicked out of public and private schools.

My community of classmates expanded from that of just my little brother in the desk beside me to a larger group of students my own age. The academy marked the first time in my life that I could receive feedback and encouragement from

instructors other than my mother. It was marvelous, and I soaked up every bit of it as a learning experience in its own right.

When the price for enrollment doubled during the beginning of what could be considered my sophomore year, it became clear that there was no way we could keep up with the payments. My interactions with students and teachers came to an abrupt end, as did my sense of community. In one act of cancellation, I had lost friends, future plans, and my graduating class.

This left my mother in a bit of a scramble to come up with some new form of curriculum. With the thought of going back to the days of dry books and half-hearted audio tapes seeming too appalling, that left only a handful of other inexpensive ideas. We started stitching together bits and pieces of what I would do with myself for the next three years—a consumer math workbook from the 1970's, an introduction to high school chemistry book found in a yard sale, a DVD set of lectures for algebra II, etc. Save for the consumer math, my mother could offer very little to no help on any subject. I was without guidance, without an instructor, and utterly without motivation. Sounds like high school, right?

In addition to the disconnection from the outside world, things at home weren't exactly sturdy. My family was shifting apart and we feared losing even the roof over our heads. By the

second semester of my sophomore year, I felt that I neither had steady home nor steady schooling to rightfully call myself a "home-schooler." In fact, the only things I felt confident and motivated to learn at all were history and linguistic studies. I spent more time studying Japanese *hiragana* and the Hebrew *aleph-beth* than I did studying formulas or how to calculate costs of living based upon 1970's tax rates. I was far more interested in the history and structure of the Roman Empire than I was about the structures of chemical compounds. I was convinced that formal education was a joke, that I was better off filling myself with autodidactic glee by limiting "study time" to only the things that interested me.

With the start of my first real job at an animal kennel, I caught a glimpse of my future as the stuffy self-taught outcast without a college degree. It didn't look pretty. I didn't mind the mediocrity, the thought of doing nothing memorable with my time; it was the boredom and lack of autonomy that did me in. After a coworker of mine broke down in tears, begging me to "do something with my life" rather than ending up like her, I knew that a decision had to be made.

The main obstacle remained the shortage of guidance and order in my life. My household was full of animals and absent of structure; I had money for the first time but nowhere and no way to spend it. Home life had solidified into an insanity from which I needed escape. I desperately needed the opportunity

to break away—and this opportunity, I felt, could come through education.

By my junior year, I was completely on my own when it came to curriculum. Realizing once and for all that the only incentive I would ever have for finishing my high school studies would have to come from within, I took the reins which had been thrust upon me and began to direct my own education. I took control of my English studies by gathering *Norton Anthologies* and grabbing classic novels off the sale rack at local used book stores, took to reading *For Dummies...* instructionals on anything from physics to languages, and found online tests and quizzes and placement exams. In short, I was responsible for my own acquisition of knowledge, and for testing that acquisition—for better or for worse, I was my own checks and balances.

This continued on into senior year, with the addition of looking toward an affordable college. What could have easily been the end of my push for academics turned into the chance to find self-motivation. This is something that has served me well in years since, a form of reminder of the ability I have within to structure myself even in the midst of distraction. Somewhere in the madness, in the embrace of the chaos, I found a way to prepare myself for college and a life of learning.

Heather Dent attended high school in Rigby, Idaho. She graduated from Berea College in 2011. She majored in sociology and is now pursuing a career as a high school English teacher. She enjoys writing poetry, listening to audio-books, and doing jigsaw puzzles. She currently lives with her husband and two year old son in Berea, Kentucky.
Submitted in written form.

Lack of Romance

The Breakfast Club. Footloose. Grease. My high school life lacked the glamour and drama of what these, and other high school movies, would have me to believe normal. I didn't belong to a cliquish group of best friends. I didn't have a boyfriend. I didn't smoke, drink, or have sex. I never even kissed a boy until my freshman year in college. In comparison to the lives of the dazzling characters of Hollywood, my life was incredibly dull. I felt like I was doing something wrong. While I was supposed to hate my parents, I loved my parents. When I should have been going to football games and parties, I mostly stayed at home curled up with a good book. To me, my high school experience was watered down, monotonous and insignificant.

If I could go back in time and talk to my introverted teenage self, I wouldn't say, "You're lame. You need to get out there and be social." I would probably say something like, "Don't feel like you need to be someone you're not. You have an amazing future ahead of you, and your social life in high school will have very little impact on that future. Just be comfortable in your own skin." Unfortunately, time travel has not yet been invented (at least to my knowledge), and I was left to make my way through high school feeling insecure and disappointed in my bland, uninteresting teenage life.

I really wasn't that anti-social. I played on the varsity soccer team. I ran track and cross country. I worked on the yearbook staff. I was involved. I had friends. I had a respectable social life. The only major problem with it was that it lacked romance. As a kid, I had an easier time making friends with boys than I did with girls, so I figured that I'd be really popular with the boys when I got into high school. I thought boys would be tripping over their shoelaces just to have the chance to ask me on a date. I even practiced refusing unwanted date requests in front of the mirror. I'd bat my eyelashes and say things like, "I'm so sorry. I'm already going out with so and so." Or "I'd love to. It's just that I'm really busy with homework and I need to focus on other things right now." It turns out the only boy to ask me on a date in high school was a foreign exchange student from Germany named Sebastian. He asked me to the prom my

senior year. It was completely unromantic. He just needed a girl to go on this group date with him, and I just wanted a chance to wear my prom dress before graduation.

Forgive me, but I feel that this prom dress needs a proper explanation. My mother took me birthday shopping when I turned 15, and we came across a lovely pink prom dress for sale at Dillards. It was marked down to $40, and I just fell in love with it. At the time, I had no occasion to wear the dress, but we both figured I'd wear it at some point before high school ended, so we went ahead and bought it. That frivolous garment collected dust in my closet for two years. Proms and high school dances came and went, but my dress remained untouched. I lived in Rigby, Idaho at the time, and there was this tradition we had where the girls would wear their prom dresses to church the Sunday after the high school dances. I hated it. I was always the girl wearing her regular Sunday clothes, staring daggers of jealousy at the other girls in their fancy, conspicuous, flouncy dresses. No one asked me to the high school dances. I pretended not to care, but I did. It hurt. In fact, it hurt so much that one Sunday I went home in tears. So when I was finally asked to prom, I made a conscious decision not to wear that ridiculous pink dress to church the following Sunday. I proudly refused to take part in that barbaric tradition.

My mom says I was a late bloomer. In first grade I was the last kid in my class to learn how to tie my shoes. It also took me longer to learn how to read. I guess I turned out to be a late bloomer in the dating world as well. I never connected well with boys in high school, but as soon as I entered college, all that changed. I suddenly became popular among boys. I dated several guys, had four boyfriend/girlfriend relationships, and fell in love with one incredible man to whom I am now married. We are raising the most beautiful boy in the whole world. I feel very pleased with the way my dating life turned out. I thoroughly enjoyed my life as a single college girl, as I dated different guys and experimented with new things, but when the right guy came along I was ready to settle down. If I had only known how successful my romantic life would be, I wouldn't have felt so insecure in high school. Thankfully those days are over, and I feel comfortable and content with my life as a wife and mother.

Husam Nasser was born in 1990 in Aden, Yemen, in the Middle East. He grew up in Yemen until he was four or five. The civil war happened when he was four. He moved to Syria and lived there for about eight years, before returning to Yemen. His father had been in the South Yemeni military and took part in the war. They

had to leave the country because the South lost the war. Eventually they returned and his father was a district mayor, but because of ongoing animosity and corruption after the war, his parents are now unemployed. Husam loves to read. Some of his favorite authors are Albert Camus, Milan Kundera, and Jack Kerouac. He enjoys educating himself. He could sit and read for days. He is currently studying physics and math. He is a senior at Berea College.

Taped interview. February 18, 2013.

There's a few things that I can think about. But one of the main things, I think, that affected me – when I was seventeen years old, I did an exchange program in high school, and it was in Seattle. It was not really in Seattle. They called the area Seattle, but I was like forty miles north of Seattle in a little town called Marysville. It was my first time away from home, and I was staying with a host family. Seattle is pretty diverse, but this little town was just, like, mainly a white Protestant community, you know?

The host family that I was staying with, they were great people. I mean, they took me in for free. I didn't have to pay anything. But they had a kid who was about fourteen, I think, at that time. I mean, they had a few kids, but one of them was fourteen, and I don't think he had much tolerance for my Middle Eastern and Islamic background, and he had negative

ideas about Muslims and Middle Easterners, kind of, you know? And that was a big struggle for me. I'm staying in this country away from home, my English was really bad at that time – on top of all this, I have to live with somebody who sometimes would bring movies that make people from the Middle East look like terrorists, or – you know? And he would often snap something at me.

But many times while I was there, I mean even the high school – even though it was the biggest high school in Washington State (there were 3,000 kids) it was still mainly white and conservative. Not everybody, of course, but they weren't very open-minded. You know? I mean, there's nothing wrong with being white conservative, you know? But they weren't very open-minded, I feel, and you can see there was only a few blacks, but they'd always hang out by themselves, and Asians, but they were by themselves, too, so it was really rough being there, and I thought about, you know, maybe quitting and just going back home. I was like, "I don't have to do this. I chose to be an exchange student." I felt not very welcome. On top of this, my host brother that I was living with wasn't very tolerant toward me.

At that time, it looked super negative, you know? I was just like, "What am I doing here?" It just seemed really negative. And I could have really left, and went back home, but I decided to pull through it. I feel like this, me staying there, affected the

course of my life completely, because if I had left, or went back home at that time, I would have come back home with the idea that Americans don't have any toleration for other people. And that's it. And I would just have stayed back home and maybe went somewhere else. But I stayed, and things got better. Like, my host family, despite the issue I had with their kid – I think they noticed that and they had trouble with him, but they tried to be nice to me to make up for it a little bit. And at this school, I was able to make a few friends.

I remember I took a debate class when I was in high school there. I joined, like, half way through the semester – I had, also, issues getting into the classes I wanted to get in, and I'm *pretty* sure it was because of racism, too, because the counselor did not want me to take – they just had this new policy, and they kind of divided the school into sub-schools, kind of, and for me, "Oh, you're international students? You can only take certain classes," even though other international students were taking the classes they wanted to take.

Halfway through the semester, I talked to my host family, and she was – my host mom was great. That's why I decided to stay. The superatten – the super – what are they called?

Superintendent.

– Ok, my host mom talked to the superintendent who came forth for me, and I was able to get the class that I wanted. Even though it was halfway through the semester, I still got the class I wanted to take, and it was a debate class, one of them. I became really good at it, surprisingly, even though English was a second language. We had a competition in the class and I made it all the way to the second or third position in the class. It was like a thirty student class, you know? We debated a lot of politics about the Middle East, about Islam.

I think it was last year, I received an email from the teacher of the class, and he was just saying, "I'm quitting teaching. I'm retiring. I just wanted to say it was just great having you as a student." Even though this happened, like, five years ago. And he's like, "Before coming to the class, none of the students," I mean, he's like, "I've had discussions with the students, and they all had this ignorant idea about the Middle East, about Islam, just very narrow minded. After spending a year, or maybe a few months, six/seven months in that class with you," he said, "everybody's attitude changed" he said.

And I feel like, you know, this experience has helped me change my life positively, or build some connection with the world, you know? I mean, I know you think about the world, seven billion, and a few people in that class, and my host family, and then me coming back to Berea and meeting some people here, like, maybe not much to change the idea and kind

of break the gaps between the United States and the Middle East, but it's still something, you know? And, yeah, I feel that experience was important to me.

If I had decided to quit at that point when everything was going wrong at the beginning of my exchange program, because of my host brother and the racist counselor at the school, and unwelcoming students at the school, you know, I would have this all negative impact on me as how I view the United States, or people here.

The same scenario has almost happened again in Berea. I'll give you an example. I had a friend. One time me and her decided to travel to New York over the break. I met her in Berea, and then we were hanging out in New York one time, and I have family in Boston. I was like, "Oh, let's go see them." My uncle and his wife and my cousins. And we go there and I have a cousin, a female cousin, and she meets her and she basically became friends with them, and then after we left (we stayed only for two days) and then she goes, "Wow," she was like, "I have had these wrong ideas about Islam and women in Islam." Blah, blah, blah.

It was kind of weird because I'm a Muslim, too, and we've been friends, like, for a year at that point. But I wasn't very, I guess – I wasn't offended or anything, you know? You can't change ideas people receive on TV, but I feel like this is another person that I learned from, and now she changed her whole

attitude about how she views a billion people. Because there's about a billion Muslims in the world, you know? And one person, changing his or her attitude, will probably tell other people.

Every once in a while, I still talk to people who have this set mentality, like, "Oh, do Muslims just want to kill everybody in the West?" I've been here for four years, but I still, every once in a while, run into a student or someone from the town who still asks the same questions, like, "Do all the Muslims want to kill everybody?" Or, "Does everybody in the Middle East just live in the desert?"

It's always an interesting discussion to start, and it gets old sometimes, but I feel it's an ongoing thing, you know? And now I feel like every time I tell a person, I feel like this person will tell another person, and the other person will tell another person. Hopefully, some of this gap will be broken, and people will slightly change. I mean, even if a hundred people, fifty, twenty people change their attitude, I think this is better than having this complete wrong idea from everybody else, you know?

※

Julia Collins was born and raised in the small, liberal state of Vermont. Her family and community -oriented home town,

although progressive in many ways, was extremely small; her high school graduating class had less than thirty students, the same students she had grown up with. This poem is a reflection on events in her childhood, how powerful they were at the time, and how time has given her perspective on those events, a perspective that she wishes she had had then.

Submitted in written form.

Sixteen years,
A time of insecurities
And passions,
A time of freedom
And constraint.
What would they think?
Whether it be
A twisted face,
Or a boy
Spreading rumors.
What would they think?
A body image
Which is self-doubting,
And a soul
Lacking of confidence.
Had I known then
That it did not matter,

It would not matter,
And it still
Has yet to matter.
What would they think,
If they saw me now,
Uncaring,
And free.

Lucas Warner grew up in the mountains of West Virginia and Veracruz, Mexico. He is a senior at Berea College. When he graduates, he wants to do just about everything. As he finishes writing his submission, it's 10:30 and he's about to go out for a long night run.
Submitted in written form.

Before the Camera

I have to anticipate my heartbeats as I adjust my microscope. At these magnifications, the smallest nudge sends the image wildly out of focus. The 30 times magnification is not very impressive, but I have the lens of my digital camera zoomed in 5 times and pressed against the eyepiece, isolating only a small portion of the image in the microscope and blowing it up to fill the screen on the camera. Under the

microscope's light is the jawbone of a little brown bat (*Myotis lucifugus*), the sharp and rugged topography of its teeth revealed in stunning detail. I struggle to move the tiny jawbone into focus, and when I get it, I snap a picture. The canine tooth, just 0.05 inches long, barely fits into the field of view. Later, I take a photograph of the tiny skull balanced upon a bear tooth, the juxtaposition creating a strange effect of proportion. Then on a light box, I photograph the semi-transparent bones of the bat's skull.

I have often wondered what it would have been like to have grown up with a digital camera. Now that I have one, I take it with me everywhere I go, and it affects how I experience things. I climb trees for interesting shots, or I spend hours on moonlit nights taking long exposure nighttime photographs, or I follow a group of kayakers through a snowstorm deep into a canyon just to photograph them dropping into the rapids. I pay attention to things with my camera in mind, eager to capture my next good or interesting photograph. I even see memories as through a camera lens. I don't mean that I see my memories as photographs, necessarily, but in my everyday musings through my memories, I find instances where I almost reach for my camera. Even in real time, it is rare to come away from photographing something with a photograph exactly how you had imagined it would be, but I like to think I would have some fascinating pictures if I'd had a camera my whole life.

One scene in particular sticks in my mind: The school bus had dropped me off at my driveway, and I was walking home (it's a long driveway) when I came across a dead black rat snake. I bent to pick it up, then noticed what had killed it. Protruding from the snake about six inches down its length was the front end of the body of a chipmunk. Its fur was slimy and matted. Its dead eyes bulged from having been constricted by the snake, and its hind quarters were still inside the hole from which it had clawed its way out. From what I could tell, the snake had apparently not squeezed its young chipmunk meal long enough before swallowing it whole. The chipmunk must have regained consciousness 5 or 6 inches down the snake's esophagus and torn its way out of the belly of its predator, killing the snake, before finally dying in what became its second struggle of the day. Could I have recalled this scene from memory had I externalized some of the experience by using a camera? Maybe not.

Maybe I learned to pay attention because I did not have a camera growing up, and maybe the reason I enjoy photography so much now is because I have been training my eye to see the beautiful and interesting because I am drawn to those things naturally. Maybe, then, the camera is just an extension of what I have always done, and I have become addicted or compelled to now record what I have always seen.

C. Brobeck *was raised in Idaho and Las Vegas and has again put down roots in Berea, Kentucky. She loves the Truth, pearls, and sea turtles. While she hopes to travel extensively, she is also extremely concerned with the wellbeing of her home, Earth. She hopes to be known for the fruits of her labor and to learn many, many languages so that she can speak with more of her human relatives.*
Submitted in written form.

I think all children are self-absorbed, even when they think they are not. I certainly was. I might have decorated my room with maps but my world was hardly bigger than a 1,000 mile radius inside of the US. I thought little about the lives of people outside of that circle or the influence that our lives had on each other. Every so often I dreamed about faraway places and meeting people that call those places home, but harsh realities were mere fiction in my naïve eyes.

In high school I had a job, a car, a love for Spanish, and a lot of excuses. I followed a path that always made sense and involved lots of encouragement from family and friends. That isn't to say that I always did what everyone wanted me to, but I rarely did anything that I didn't have support for. I could have exposed myself to a lot of things that would have awakened an

extraordinary love reaching beyond those 1000 miles, but I didn't.

To some degree, I believe we will always think first about that which we encounter every day. It takes effort to keep up on world news, watch documentaries, and research other cultures. No one can fool me into thinking that it's easy to be selfless, a cosmopolitan-minded person, or multilingual. You have to think twice about everything. You end up making friends that you don't see very often or who may be in harm's way. Travel becomes a desired hobby, death tolls and human rights violations often accompany your morning coffee, and you begin to wonder how much that new pair of jeans really cost.

Think about your worldview for 30 seconds. If you can't come up with anything, take another 30 seconds. If you do, does your world focus on your country? Your language? Your culture? Yourself?

At 14, my world was still about me, but for the first time it began to grow. In my freshman year of high school, I began taking Spanish. Once afforded a new vocabulary, my ideas began to burst my 1,000 mile radius bubble. Suddenly, I needed a map for more than decoration; it became relevant to my thoughts, my dreams, and my worldview. For the first time, I began to seek out the "latest" in other countries. Slowly, due

to my selfish interest, I began to see beyond myself and my society.

I recently found a quote on Facebook (of course). It says, "Other cultures are not failed attempts at being you." As a white person, I think all white people grow up with a certain sense of superiority that we either blindly accept or spend a lifetime rejecting. To overcome this racism, we must follow passions that contradict this prejudice. My mom always says that recognizing the problem is always the first step to making a change. In this case, I didn't initially recognize the problem, but I did change myself and thankfully those changes have lasted and multiply daily.

At 21, I can't imagine having been a closed minded, monolingual, self-absorbed person. The funny thing is that when I was that person, I began walking in the other direction.

Damya Reine *was born in 1990 in Casablanca, Morocco. She grew up there, and then came to the U.S. when she was 16 to attend high school for a year. She moved back to Morocco for three years before returning to the U.S. to attend Berea College. Her interests include watching documentaries about history, learning about historical monarchies, Middle Eastern dancing, playing badminton, shopping, and swimming. She is a senior at*

Berea College, where she is studying Business Administration with a double concentration in Management and Marketing. Taped interview. February 23, 2013.

Well, my middle school and high school until the tenth grade was totally the same. Nothing specific happened that made me grow from anything. Just, you know, growing up like everybody else in a society where everyone is the same, and we all have the same stereotypes and all that. So, when I turned sixteen, which is when it was time for me to go to the eleventh grade, I applied to this exchange program, where students can go to a high school in the United States. So, I came to the United States, to Chattanooga, Tennessee.

So, I came to Chattanooga in 2006. I came here, and we have host families – we were supposed to be placed in them. So, I was placed with a host family that was African American, and I did not choose to, but I grew up in a society where, you know, we have our own stereotypes about people of color, and I was young. That's all I knew, because we do not have access to outside people that are dark in our country.

So, I grew up thinking and believing what my family believes, you know: "Oh, they're bad," or the media, through the American movies. They're usually the gangsters, and so on. So, I came to that house, and the people were African American, and I was kind of scared. I was scared. I don't know

what I was scared of, exactly, but I was just scared, because I grew up thinking that they're bad, basically.

So, then, I called my coordinator and was like, "I need to move from this house right now, or I will go back to Morocco." So, she moved me from there after two days. I lived with her, and then I kept changing host families until I settled down.

Then, school started, and she drove me to my high school, and it was my first day of high school, and on the way there, she was saying, "Well," – she's trying to get me ready, I guess [*laughs*]. She was saying, "This is going to be a different high school," and I said, "Why would it be different?" and she said, "You probably notice, you know, how high schools have a lot of white people? This high school is the total opposite. Ninety-nine percent of the students are black."

I could not imagine this in my head, because I did not know that, you know, people can be that isolated – have a high school of African-Americans and a high school of white people. I did not know that existed, especially in the U.S., and I was like, "Whoa. Great. I'm about to die." [*laughs*] I was so scared.

So, I went there. I stepped the first step into the high school and I see this sign saying, "No guns inside." That made me more scared.

So, I go there, and I go in – it's my first class. It was an English classroom, and I entered, and everyone was staring at me, and I felt so awkward. I was like, "Okay, let me smile at all

of them, so they will not do anything to me." So, I kept smiling, and I kept saying, "Hi," which was so awkward, because I kept saying, "Hi," to everyone, and I didn't even know them.

So, yeah, I was scared for, like, a week, until people started talking to me, and I met other exchange students that were like me, one from Germany and the other one from Bulgaria. So, we became friends. I found a comfort zone, then I could expand into knowing other people, and that's how I met a lot of friends that are African-Americans.

This is what I thought: I thought they were very violent. I thought I would never want to be friends with any of them, because all they do is hit each other, and kill each other, and steal, and all the bad things you could imagine.

And then, I was *so* glad I came here and discovered that this is a stereotype, basically. It's just like saying that, "Hey, I'm from Africa. In Morocco, I ride camels and I live in the bushes." That's the exact same thing, because people in the U.S. think that about me.

So, I was so glad to come here and break the stereotype. It was amazing, because I met so many great people, and, basically, there's no difference. There's bad white people and bad black people, and I learned that you cannot judge a person by their race.

So, about five months from when I came there, I met this guy who was African American, and I started liking him, and we

dated [*laughs*]. It's funny. I would never think I would date an African American guy. It was funny, and my parents would totally not agree with that, either, so I didn't tell them, but it was a great experience. I really enjoyed spending time with him, with his family, and they're really great people, and it's because of that high school, and it's because of the realization that people back home are very closed-minded when it comes to people who are different from them, that I did not want to take part in my culture back home anymore. I do not want to be that person who judges a book by its cover, basically. I did not want to do that, and it's not that I reject people from back home. It's just that I choose not to be part of their thinking. So, I try to do everything differently, stand up to someone who may say something bad.

When I would go back home, for example, after that experience, I would go into a meeting with a lot of friends that are our age, in their twenties and so on, and there would be a person coming of a dark skin color from the south of Africa, and they would make jokes, and I would literally stand up and go hang out with that person, because I do not want someone to be left out just because they look different, which is something that they did not choose in the first place, and which is something that is not bad in the first place.

Then, when I went back home, I was pretty much crying a lot, because I realized that I had such a great life while I was

here, because my mind just opened, and I just realized, "Oh, my God. This is life. It's not a life of 99% Moroccan people. It's diversity." So, I wanted to come back to here, and this is how I applied to where I am now. And I got rejected the first time [*laughs*], but I applied again, without telling my parents, until I got admitted, and then, I was like, "Hey, Dad, Mom, I'm going to the U.S. again."

So, that's what happened, and it changed my whole perspective, and my whole view of, not only people of color, but anybody. Now, before judging anybody, like, "Hey, you're from India," or, "Hey, you're from Japan," I do not care where they're from. I care about who they are, and that's what matters to me, and I love – it makes me happy to know that I am like this. I mean, I know the majority of the people in the U.S. are like this because they grew up in such a diverse environment, but I did not, and I'm glad I changed. If anything, I'm very thankful for being in the U.S., for what it has given me. It definitely has opened my mind.

Monica Leslie *is an administrative and career development professional. She applies principles from her professional experiences to connect to her students' lives and assist with their character development. In this story, she reflects on her work experience as a cattle farmer to explain how fear in animals, as*

well as in people, hinders growth and personal development. Using cattle work as a metaphor, Monica provides a provocative exploration of how trust in relationships makes the difference between hurting and healing, and of how trust enhances our relationship with God. Her Facebook name is Monica Philosophergurl.

Submitted in written form.

Chutes and Bladders

Monica Philosophergurl shared a link:

"Sometimes we catch ourselves paralyzed by fear b/c we don't know what lies ahead, but we do realize we're not gonna like it. We drag out our suffering due to our own internal resistance. Perhaps establishing trust means that we must surrender ourselves and allow God to work on us, other times it means we must feel our way out carefully before we can have faith in those who shepherd us; but whether we choose to go graciously or kicking and screaming, we have to get through that chute before we can be free or move forward."

Below the glaring electric laptop screen was a link to a Youtube video of the song "Float On" by Modest Mouse. It was 7:30 in the morning.

A flood of memories rushed back to me. I thought of the days I spent working with goats on the farm. It was one of those

memories that, ordinarily, you wouldn't mind sticking with you when you had a chance to look at the big picture; especially when you notice the pastoral significance of those moments. But when you try to wrap your mind around the messy reality of the event, of wild, skittish animals, lured into a false sense of security – then frightened by changes they can't understand, you understand what it means to be literally paralyzed with fear, crapping yourself, and all of the attempts through the struggle, coaxing, and prodding make total sense – if looked at in the right light.

As a vegan, many found it odd that I raised goats, pigs, and cattle. I believed it might provide a valuable learning experience. I do recall, however, that I had difficulty capturing the animals. Rarely would you see me wrestle one to the ground. I never gave shots, or inseminated animals. I can't even say that I did a very good job of trimming goat hooves – too much oozing and goop gushing for me. What can I say? My own history of domestic abuse, and perhaps silent over-identification with the animals, would not grant me the disposition to do anything I believed might be "too invasive." Instead, I took on the role of ensuring that the animals weren't too much of a danger to themselves, or others. Turns out, this level of awareness made me a good foreman.

What I was really good at, however, was luring the animals out of the field and into the chute. The animals knew to

associate my cattle call with food and water. I studied their behavior and knew which animals trusted easily, which ones became distressed when abandoned, and where to position myself so that I could navigate them around the field with minimal interference. Once we had them in the chute, however, it was a totally different story. Once the animals could see us, it was difficult to work the animals, because their first inclination was to succumb to fear.

Occasionally, the kids, unfamiliar with what was going on around them, would drag their feet or cling closely to their mothers. This made them a little easier to catch, but definitely more complicated to work with, especially after their mothers had been taken from them. Their resistance often brought unnecessary suffering, particularly for those that were clingy or unsure. Most of the time, the anxiety leading up to the time they spent in the chute was more traumatic than anything we had actually done to them. I remember a young kid, flailing around so much while the cattle handler tried to ear-tag him, that the goat ripped his head away from the ear tagger resulting in a shredded ear. Can you see why I never wanted to be involved in creating associations that would generate fear?

I wanted to work with the cattle in the most humane way possible. That meant knowing when to act swiftly. On occasion, I would have to distract the animal or move in quickly to

quietly intervene before the animal had time to feel threatened or react with fear.

Secretly, I knew that at any moment, one of those cattle could trample me to death. I'd been charged at during a cow/calf operation on my first day of working. We had to separate the cow and calf to take the calf's weight and ear-tag it a few days after it had been born. The mother was FURIOUS, to say the least. So I was always a little more guarded around the cattle when we were working with them. It was easier to use coaxing and pressure points to get them to do what you wanted to do. It was just difficult to get them to understand, sometimes, that they didn't have control of the situation the way that they wanted to, and I know that was distressing for them to experience from time to time.

It was hard to know what to expect. On the way down toward the pasture, two bulls got into a fight. While they were butting heads and braying at each other, my boss, Bob, walked in and shoved them forcefully yelling, "HYAH, HEYAHHH!!! GIT ON' OUTTA HE-YAH!" Although tall and lanky in physique, I doubt that the bulls even felt the physical force of Bob's impact, but you had to give the man credit. He had a spectacular way of making his presence known. For some reason, Bob labored under the impression that I had some sort of similar presence with the cattle, and although I didn't really see it, and often felt

a mixture of excitement and being terrified, I didn't want to let Bob down.

As I peered at my Facebook status, I thought about similar correlations from my past. I thought about all of those times in my life when I became resistant to change. I just knew it was going to be painful – which made it very difficult for me to trust God's plan. By not understanding what I was, or how the process would benefit me, I often prolonged my own internal anxiety, or caused more damage by resisting than was initially planned. I wish I had not let the fear get the best of me. I wish I had have had enough trust to put my best foot forward and to put myself in God's hands.

*The **writer** of this piece is a twenty year old Kentucky girl, raised by a television set, books, and copying her older sister. She currently (slightly reluctantly) attends Berea College as a sophomore, where she plans (maybe...) to study agriculture. If you can't already tell, she's not too sure about much of anything. But for the most part, she's okay with that.*
Submitted in written form.

There are so many things
That I wish I'd known

At thirteen, talking friends out of suicide

Sitting on the floor in social studies.

At fifteen, stressing over grades

Perfecting every assignment for an A.

At seventeen, running myself wire-thin,

Becoming nothing but a passion-less skeleton.

At nineteen, searching for myself in others

Disguising my personality behind selfish desires.

At twenty, learning to accept the person that I am

Sipping coffee in college classes in order to stay awake.

I thought I'd know who I was by now,

But every day is something different

I'm still lost

I'm still thirteen, fifteen, seventeen, nineteen

I wish I'd known

That it's okay not to have everything figured out

That it's okay to be who I want to be

That it's okay, at age twenty, to still be wandering.

The author of this piece has been a student at Berea College since August 2012, and will graduate in 2016. His name is **Lewis Kilongo***, and he comes from the Democratic Republic of the Congo, where he completed his high school education.*

Submitted in written form.

My education had been interrupted a number of times due to different challenges—financial constraints and war situations in the Eastern Congo where I went to school. I had completed my high school education in 2002 and started college in 2004, but I was not able to finish because of the aforementioned challenges. At the moment, I am pursuing my education at Berea College. I found this opportunity to start college, and actually hope to complete it, ten years after my graduation from high school.

Although I used to be very studious and enjoyed school, I think that being back in school after all these years has made everything very stressful and less enjoyable. During my first semester at Berea College, I have noticed an uncontrollable pressure to work extremely hard in order to succeed, because, for me, this opportunity seems to be the last chance I have to catch up in life. If I miss out, I feel like I will lead a miserable life. I now worry so much about everything, because I feel like I do not belong in any college environment anymore, and that I am way below my standards, since all of my classmates are considerably younger than I am, et cetera. This fear causes me to stress much about every single assignment and test in school. I find myself working till very late at night just because

I do not want to fail. All of this pressure comes from the fact that I feel too old to still be in college.

Although most of the circumstances that had caused a delay in my education were beyond my control—wars and financial constraints—I still wish that in high school, I had been aware of the kind of feelings that are generated by getting one's college education later than normal. Had I known how demotivating and heartbreaking the feelings could be, I would have done my best to avoid spending that much time pursuing my college education.

During my previous visits to the United States of America, I had met a considerable number of young Americans, females and males, who did not want to start college after high school graduation; not because they could not afford it, but because they simply did not feel like starting college yet. Since that was before I started college, I had nothing to say to those people. From the day I became aware of possible challenges that result in delaying one's education, I decided to start encouraging young people who choose or consider not to pursue college education soon after high school graduation just because they don't yet feel like it, to think twice about such a decision, because school would become more challenging than it really is. Instead of it being an enjoyable experience, it would become very stressful, because, when pursued late, education is much more likely to be looked at as the last solution to improving

one's living conditions. Just the idea of education being the "only solution" has a strong potential to put someone in a position to consider a degree that would help make a lot of money. In such a case, an individual would not have a different option but to sacrifice her or his passions and dreams—things that are easier to pursue when there is no pressure to work hard in order to catch up before it's too late.

<center>❀ ❀ ❀</center>

***Marisela Rodriquez Gutiérrez** was born in Pénjamo, Guanajuato, Mexico. She enjoys discovering new music, watching movies, and reading about other cultures. Her father makes fireplace doors and her mom makes sausages. She has lived in Milwaukee for most of her life. When she and her family first moved to the United States, Marisela was twenty months old. They lived in California until she was four. She recently got her bachelor's degree from the University of Wisconsin in Milwaukee. She majored in Film Studies and she has a certificate in Latin American and Caribbean Studies.*
Taped interview. January 5, 2013.

Something that I wish I would have known was that everything was going to be okay, because since I'm undocumented, I always had problems justifying why I work so

hard. I was always an overachiever in school, and at times, during high school, I would think to myself, "Why am I working so hard if I'm not going to be able to do anything with my degree?" Or, like, "I'm not going to be able to go to the school that I want to."

In my high school, you could take as many classes as you liked – as many as you could fit into your schedule. It was a different kind of school and I would always take so many classes. One semester, I had nine classes, and I had no time to eat or anything like that. My dad would be like, "Marisela, what are you doing? You should, you know…" I mean, he always supported me, but I would just be crazy and taking all these classes and then at the end, it would be like, "Oh my God. I'm exhausted." And then I would be like, "Why – ?" Especially when I was a senior, I was just like, "Why did I do that? I'm crazy. It's not going to make me a better candidate to go to a school that I would want to go to, because I can't." That was my mentality. I can't do it, so why did I work so hard? And then I would cry about it. All the time, I was very sad about not being able to go to a school because of my status in this country.

Now, I know that Obama has this temporary program or whatever, but in my personal opinion, it's like a temporary Band-Aid on the whole immigration stuff right now. I mean, it's an opportunity that's making an aspect of my life easier. I just graduated from college, so I can actually find a job that's

related to what I'm studying, at least, or any job. It's something to grasp on and be able to do something legally.

What would you say to yourself if you could go back in time to that point in your life? Or, what would you say to someone in a similar situation?

I would say, "Chin up, kid. Chin up. Something will work out. Something always has to work out. And something will always work out, especially if it's this kind of problem that's a social problem. Something has to happen. People are fighting for us and you should fight for yourself. Don't give up, because something is gonna happen." Something is happening now and something will happen positively, I think, for the youth. So, I just want to tell people, especially kids, and younger people than me, to not give up. And I know I had really positive role models during my life like my parents, my teacher, Raoul, Ms. Dinorah. They would all just be there, telling me to not give up or think negatively about anything. 'Cause something will change. Something's gonna change, and we're just waiting, and then it will be history.

Another thing that I was thinking about during high school was that I actually went to a school that was, I would say, 75% white, upper-class kids that had a lot of money to pay the ridiculous tuition that was, like $9,000 a year, more than my

university tuition every year. I was part of a small group of students that got this thing called the Choice Program, which means you go to the school on scholarship. But there were not that many Latinos, and that was a culture shock for me. So when I was a freshman, I came from this school that was, like 99% Latino kids, and then I was going to this school where it's predominantly white students, and it was culture shock.

As the years went by, it got better, 'cause I got used to it. But, when I was a senior, and being an undocumented person, I felt like I was the only one going through what I was going through. I definitely don't remember anybody like me at my school. I mean, there probably was, 'cause there were some Latino students, but I didn't know them. We didn't talk about it like that.

When I was in middle school, I was hoping that something would happen by the time that I was a senior that would make it easier, but nothing ever did. I felt lost.

It sounds like I didn't have anybody to talk to about this, but when I started applying, this very nice teacher that also went to my middle school – and she taught at the high school where I went – she really was really helpful and brought me all these applications and helped me apply for these schools. I applied to four different colleges, and I got accepted to all of them except for one. But that was a really hard one to get into, so it's no problem, you know? I had three different school choices and I

chose the one that I thought would be better, 'cause I like the city, so of course, I chose to go to UWM Milwaukee. Anyway, I lost my train of thought. What was I talking about? [*laughs*] Oh yeah. Culture shock.

Yeah, so, I mean, that's one thing. I would say to people not to feel like they're alone in their problems, 'cause they're not. Now that I'm in college, or that I have been to college, I have met so many more people that were going through the same things as I was, and those people didn't let that get to them, either. And we're all really close now, 'cause not everybody can understand – like my dad says, not everybody can understand what you're going through unless they're going through the same thing as you. 'Cause there's people that criticize, and don't really know much about the topic, and just stay with their opinions and don't want to learn. I would just say, "Your experiences are what make you who you are at the end." Especially for me, this experience, I know now, has made me a stronger person. My dad always says that, too. 'Cause I've had friends that get everything paid for, and they haven't needed to have a job, 'cause they have everything paid for by the government. My dad always says, "I think you're going to cherish it more at the end, because you know how much it has cost you financially, and emotionally, and everything."

The subject *of this interview was born in 1991 in Martin, Kentucky and grew up in a little place called Gays Creek in eastern Kentucky. He is a second semester junior pursuing a degree in Appalachian Studies at Berea College. He loves food and he thinks that food is a great way to bring people together. He loves to engage with people and learn where they're from and who they are. He came to Berea as a music education major, but after taking one Appalachian Studies course, he quickly changed his mind. He loves to sing and to play the piano, and he is learning to play the guitar. He thinks when he uses terms to describe himself, it defines him in a unique way. For example, when he says he is a Presbyterian, it doesn't mean he believes what all Presbyterians believe, or if he says he is gay, it doesn't mean he is like every other gay person. But, yes, he is a Presbyterian, and he is gay, and he is a Democrat. He considers himself a "mountain boy".*
Taped interview. January 27, 2013.

To really get into this story, I will have to tell you a little bit about my family. I am an only child. My mother had two miscarriages before me, and almost miscarried with me. If exactly what had happened during the pregnancy and labor had not have happened perfectly, both my mother and I would have died. So, I was born almost miraculously. Because of that,

I am very close to my family and they're very close to me. I'm the only boy on my mother's side. There are five cousins: two girls older than me and two girls younger than me. We are a very close-knit little group, but I am the only boy. And then on the other side, I am the only grandchild. Because of the strong connection that I have with them, open communication has always been very important with our family. We don't hide from each other, we don't keep secrets from one another, and one problem of one person is everyone's problem. And that's just the way it is.

My two younger cousins, I have seen them every single day since they have been born, just about. They live two minutes away from my house. We all went to the same school. I went to a K-12 school. It was public, part of the Perry County board of education, but the school only had five hundred students K through 12. So I graduated with forty-five. Fifteen of us had been with each other since preschool. So, on top of me being so close with my family, I was also close with my community and with my friends. That created this very interesting world that a lot of people do not get – that they're not a part of. They're completely this supportive, welcoming, wonderful community that I was a part of, which also included my church family, because my church family and my school family were basically the same people. The church and the school at one point in history had been the same. It had been a Christian education

program, and then in the '50s, they had split for various reasons. But, the church was where we have our graduation, that's where I go to church – very close. So, most everyone who goes to my church graduated from my high school, you know, that type of thing. Three of my four grandparents graduated from my high school, so as you can see, there was this complete bubble.

I grew up knowing that if I had a problem, I could share it with my family, and it was part of them and they would have accepted that. That was pretty much how it was until around 7th grade. And also around the 7th grade, there were two things that were happening in my life that very much relate to this question – things that were affecting me that I did not think would have ended up positive, that I thought would have had a negative impact. Or, for some other people, would have had a *very* negative impact.

One of those things I'll talk about first is my father, who is a wonderful human being. He is one of the most intelligent men I have ever known. He is – was a medical technologist for a hospital for 15 years. We have a woodstove in our basement that helps heat our house. We have central air and heating, but it just is nice. So, he bent down to put a log into the fire, and a disc ruptured in his back. That – long story short – caused him to lose his job. Not because he wasn't able to do his work, but because the administration told him that if he didn't quit

himself that they would fire him, because he was destroying his health. Which was true. He could not stand for 12 hours on a cement floor. Basic fact. And so, he refused to leave, of course, and so they fired him, which was good. It's what they needed to do. He was destroying himself.

So, after 15 years, he no longer had a job – a job he very much loved. And he also couldn't work outside. He's a farmer and an outdoorsman to the fullest extent, and he couldn't do that anymore. All that related directly back to the fact that his life completely changed, and when his life changed, ours did, too. Mom was the main income provider. I was having to help out more at the house, you know, do outside things that we needed to get done, as much as I complained about it.

And then, on top of that, because he was not able to do those things, that lead to – which is very genetic in our family – bipolar and depression problems. My grandmother, his mother, had hurt her back in a car accident and had basically laid in bed for a year. Our family has a genetic make-up to cause us to have depression problems, which we kind of suspected would kind of be the end result of all of this, and he did, too. And so, that has really caused a lot of struggles within our family.

He could easily take mood swings, which was – he was never abusive. Oh, my gosh. Never, ever, ever. Oh, if he had have been, I would have punched him right back in the face. [*laughs*]

Our family are fighters, honey. We wouldn't have took none of that, and neither would my mother. Oh, my God. She'd have killed him. But, he would just take mood swings and it was really hard to work through that when he would just immediately snap [*snaps fingers*]. And, you know, he would be so angry at just – nothing. Absolutely nothing. And then five minutes later, he would be fine. That's really stressful on a family that had been so close.

While that was happening, I decided that – I was figuring out that I didn't like little girls. So those two things were happening all at the same time. And yes, I really thought in the very beginning that it was going to be a – not end positively. I thought that it was going to tear our family apart if I was to come out to them. And it would have. My mother could not have handled that on top of dad's problems. Nor would I have wanted her to.

I made the decision to not tell them, which I also didn't know if it was going to end positively or not, for various reasons. One, I was afraid that – so many stories I had read about – it just ate away at me, and I needed to get it out of me. I needed to tell, and I thought that that would become who I was and that that would be me. That was one concern. And then also, I was so afraid that when I did tell them – I was never afraid that they would turn from me. That was never a question. I was always more – my grandparents, yes. They're a different story.

But, my parents and cousins – my generation and the generation before me would not have. But, I was more concerned that my mother and daddy would be very upset that I hadn't told them, because, you know – full circle back – we go back and – our problems. Not your problems. *Our* problems. And so, our situation, it's a support system. It's a web. And so, I continued to not tell them, for a very long time. And Dad has been suffering continuously since then, but over about the last two years, I think he's doing a lot better.

Did it end positively? Yes. It has ended positively. I was not sure that it was going to. It did not eat away at me. My sexuality did not bother me. I was very much afraid that it was going to at first. People had always talked about how it was, like, they *needed* to tell. Well, I didn't need to tell. It wasn't something for me. It wasn't the right time, and I knew it. And so, I went on my daily, and didn't worry about it. So, I stayed in the closet, if you want to say, until I came to Berea.

That was about 7 years that I didn't say anything, and was not one bit upset about it. It was for the best. It was not the right time for my family. It was not the right time for me. In my high school, I was as active as I am here, so if I had came out, it would have been a shock to – I don't know if much of a shock, but it would have been very much a barrier for us to achieve what we needed to achieve. A barrier for the organizations that I supported and was involved with. It would have caused us to

not have had as much potential and I felt like it would have been a setback, which I guess still goes back to my thinking about the whole, and not just myself. I've always analyzed that so much – that I am just so truly invested in believing that we work as a body, as a group, and not so much as an individual. I am so independent, and such an individual person and so confident in who I am, but I work so much for the whole. That's always been very interesting to me – analyzing the whole situation.

I didn't come out until I came to Berea, and so I *did* come out. Of course, now we get to the other little section about was it going to end up positive or not, and of course, I knew exactly my mother's response. She was tore *all* to pieces that I had not told her and that she had failed me as a mother, because I did not feel like I could've come to her and tell her. I said, "You are *so* conceited." [*laughs*] That's what I told her. I was like, "This is not about you, mother. It's about me." And not even so much about me, but it's for everybody. I said, "You did not fail me as a mother. If you had failed me as a mother, I would never have told you. Never. If you had failed me as a mother, I would have told you a long time ago, and I would have left you. But you didn't fail me. Far from failure. Far from failure."

So I told them, and my dad is perfectly fine with it. His response has been much more positive than my mother's. She is always concerned because, at the time that I told them, I had

a boyfriend, and she was so concerned that I would be in a relationship and that would hinder *our* relationship. That someone has something that she doesn't have with me. And that is, as her only child, that is difficult for her, and difficult for me to handle and try to comprehend, because I know better than that. I know that that may be true, but our relationship is solid. There is nothing that comes between she and I. Dad, on the other hand, has been *very* okay with it.

We were back – last summer – he and I were driving somewhere, to town or somewhere. I don't remember where we were going, and he looks at me and he said, "Do you have a boyfriend?" And I was like, "No. I don't have a boyfriend." But that moment was just so weird to me, so nonchalant, that he just asked and it was no big deal. You know? That was great. I never thought that we would – I did with Dad, actually. I thought that he would be much more okay with it. Dad is a very open-minded person. Easy-going, whatever. Mom, I don't think – I would be very interested if she ever gets to the point where she was to ask me something like that. I would probably have to tell her. Just because she just still sees that as a hindrance in our relationship, which is understandable, you know? Your only child telling you that they're wanting to face the world with all of that mess and then on top of that, trying to find a relationship which would be a different relationship and have

something that she couldn't have with me, you know? Which is completely understandable. Completely.

Would it be different if you had a girlfriend?

No. Good question. I'm glad you asked that. It wouldn't have, actually. The only thing different would be that it was a girlfriend, not a boyfriend. And she very much said that to me, because she has been very vocal about this. She told me, "I can deal with this. This is not a problem." But she's like, "I cannot deal with you having – are in a relationship." I was like, "Okay," and she's like, "Please know that it is not because it's a boy. If it was a girl, I would be the exact same way," and I'm like, "I do know that." It's just that some other person has my attention other than her; some other person has a strong connection other than her, and that I would be making a decision with this person and not her, because she and I have made decisions together. She is my go-to. She still is my go-to, and I tell her that all the time. I call her and talk to her about – if there's anything that I feel that there's a problem about, I discuss it with her, but to think that I would make a decision based on someone else's feelings other than hers and mine, or Daddy's, is just so – or, you know, outside of the family, is just really difficult for her to comprehend, which is completely

understandable. Completely understandable. It's been interesting to see us work through that together.

That's one thing that I did not think was going to end positive, based on Dad's problems and Dad's situation and my own personal situation converging. I did not think that the entire thing would end up positive, but it has. Very positive. Much more positive than other people have had. Very much more positive than other people have had, and I am very blessed and thankful for that.

Part Two

Tell me about something you wish you had done differently when you were younger or some aspect of that time (whether it was something you were doing or something that was happening around you) that has shaped who you are today.

John Warner *was born and raised in Ohio, went to school in Pennsylvania, and has spent a major portion of his life living, working, studying, and traveling throughout Mexico, beginning with a two month car trip with his family at age 8 in 1953. He is married and has two grown children, both of whom he has been taking to Mexico since they were little. He continues to divide most of his time between his family's home in the mountains of rural West Virginia and living and exploring in the mountains of rural Mexico.*

Submitted in written form.

There's a story from some 40 years ago that reminds itself to me with considerable frequency, but I've never written it down. I have found occasion, from time to time to tell it (my kids remember first hearing it as small children), to the point where if any of my family ever hears me grousing about some misfortune or another that's really messing up my day, whether minor or major, they can fix my attitude in a heartbeat just by telling me, "Remember the bus."

I lived for several years in the early to mid-'70s in a little village in the Highland Mixtec Indian region of northwest Oaxaca State in southern Mexico. I was in my late 20s. It was remote – a good four hour hike to the nearest paved road. The village is in a fertile valley at about 8000 feet altitude, ringed by mountains. Nearly all the villagers were farmers, subsisting by some combination of corn cultivation (working with ox teams and wooden plows), goat or sheep herding, raising pigs, chickens, turkeys, and so on. Several of the old guys in the village were also weavers, weaving heavy wool ponchos and blankets (on big old handmade oak timber upright Spanish-style looms), which they sold locally.

I had gotten to know the master weaver in the village a couple of years earlier when I lived in nearby Nochixtlán (on the highway) while doing an ethnographic study of the regional market system in that part of the Mixteca Alta. Occasionally, I would see this old guy on market day carrying a new and beautifully woven blanket, which he had for sale in order to buy provisions for his family back home. I took several opportunities to strike up conversations with don Chucho, and he was eager to share stories with me. He was in his late 70s at that time, and he enjoyed telling this young gringo first-hand stories about the Zapatistas and the Carrancistas vying for control when the Revolution came through his village. The loom he uses was his father's, and the only loom in the village

to survive the burning and pillaging – his father had dismantled it, and buried the timbers and other pieces in his woodpile. I was fascinated by him, his blankets and his stories, and to make a long story a little shorter, a year or so later I was living rent-free almost next door to him in a sun-dried mud-brick house with a dirt floor, supporting myself by raising a garden, baking cakes and corn bread, and mailing blankets to a couple of handicraft shops in the States for resale.

The hitch was, the nearest post office was in Oaxaca City. I eventually learned from the locals which ridge tops, gullies and paths through corn fields could be cut across to shorten the hike, and I got to where, even with a backpack full of a couple of heavy blankets, by busting butt I could leave Yodocono at 4 (the air at that altitude in those mountains was – and still is – clear enough that even when there is no moon, you can see by starlight) in order to reach the highway in time to flag down the 7 a.m. bus in order to get to Oaxaca City by 9, when the post office opened.

Between trips to the big city, I would make a list of the various errands I needed to run while there (including errands I offered for friends and neighbors), and I did all I could to make these trips as infrequently as possible, like once every three or four weeks. I would plan out my hikes so that I could, again, by busting butt (actually at a run, carrying an ever-filling backpack), finish all my errands all over the city (I got to know

the city pretty well) by the time stores closed up at 7 in the evening, get something to eat, then take the 8 o'clock bus back up the highway and make it back to Yodocono (by moonlight/starlight, often with a heavier backpack than I had left with, and climbing another 1000 feet in altitude), getting home somewhere around one. Long day.

But this is not the story.

The story is about the time I asked don Chucho's daughter-in-law Amelia if I could bring them anything back from Oaxaca City, as I was planning a hike the next morning. As it turned out, her husband, Licho, don Chucho's youngest son (a few years older than me, and the only member in this generation left who was continuing the village's weaving tradition), said he also needed to go to the city the next day, and why don't we hike out together. Great, except, I explained I needed to catch the 7 o'clock bus in order to get everything done during the day. That was fine, he said, he would come by my door before 4.

By nearly four, I had had my coffee and bread, and I'm waiting by the door. Four o'clock – well, I can hike faster and Licho can jog. After four. Shit. I run up to his house. He had slept in – he's still in bed.

Amelia heats his coffee and serves me a cup. I drink it with difficulty, and very little conversation. I am so way pissed I can't even stand it. The next bus doesn't go by 'til 9, and I'm

just not going to get done what I'm needing to do in a day's time, and now I'm going to have to change all kinds of plans, prioritize what I'm doing, and make another senseless trip in a few days. I am *steaming*, and doing a real bad job of hiding it.

The hike is oppressive. *I* am oppressive. We hike together, but not together – I take even longer, quicker strides than normal, making Licho (tough as nails, but with much shorter legs) struggle to keep up. I wear myself out, so that I can wear Licho out, for ruining my day (already, says me – though the sun's only now just coming up over the mountain). God, I'm pissed, and I'm making Licho know it.

From Nochixtlán, the road, finally paved in the early 1950s, closely follows the old Aztec trading route as it begins its 2000 foot descent into the Valley of Oaxaca. The broad, rutted trail is still clearly evident as it alternately parallels and criss-crosses the highway. The choice of the route taken by the Aztecs – and subsequently by our bus – though tortuous, is obvious: as it leaves Nochixtlán, and for the next thirty or so kilometers, it follows the Continental Divide – and so requires no bridges. This is a rare blessing in a state as rugged as Oaxaca where spans from mountain to mountain across seemingly bottomless chasms are often impossible – which accounts, in large part, for the degree of isolation (and therefore relative survival) of many of the indigenous communities, particularly in the Mixteca.

In any case, Licho and I, and a busload and a half of other Mexicans, are slowly winding down the mountain, swaying side to side as the bus navigates a seemingly endless series of hairpin turns with steep and bottomless drop-offs on both sides, and I just can't quit making sure that Licho knows that I'm not through letting him know just how beyond pissed I am with him that he just screwed up my whole damn day.

And on top of that, now the god-damn bus is *stopping*! And doesn't move. And doesn't move . . . We're in a curve behind some vehicles in the middle of nowhere, and you can't see around the curve. The bus driver shuts off the motor. We sit. I pull out my list of errands I was going to run and start crossing out a few more of them. I am now getting even *more* bent.

Several emergency vehicles squeeze by us.

Eventually we start moving, and around several more bends is a cluster of police cars and emergency vehicles. So where's the wreck? Has it been hauled away? The bus starts to come alive with animated but hushed chatter. Everybody's looking over the edge – the wreck's down there – *way* down there.

It's a bus.

It's the 7 o'clock bus.

Jose V. Pimienta Bey was born on Long Island in New York in 1962. He is an Associate Professor at Berea College in Kentucky. His interests include history, martial arts, music, comparative theology, and the natural sciences in general. He occasionally tries to read for pleasure and to see a good movie.

Taped interview with written additions and edits. February 1, 2013.

[Extension of Jose's introduction]:

I am a Soul, seeking to become a greater manifestation of the principles of love, truth, peace, freedom, and justice. I am one who seeks the bridges between peoples and cultures. That's a primary concern for me, but I am also someone who is very concerned with giving back to people of African descent, in particular, our true historical reputation. Africans have contributed greatly to the human family, but this is something that has been clouded by slavery, colonization, apathy, and the baubles of "pop culture," something which might be called weapons of *mass distraction*. Through my scholarship and my life in general, I try to express the truth of Africa's value. I've dedicated my life to becoming the best example of love, truth, peace, freedom, and justice that I can conceive of. I really try to live those principles to the best of my ability and to maintain a sensible outlook on life; one where humility remains in the forefront of my mind. Each day, I trust that I may learn to laugh

more, relax more, and at times, not to feel as if I'm trying to push an elephant uphill on roller-skates. Such feelings of futility are simply part of being human. I believe that subduing such feelings is possible when we learn how to contextualize them and thereby know why they are there. This is something which Moorish Sufis have described as mastering or perhaps conquering the lower self. Ultimately, I believe that everything is in Divine Order and is improving and evolving in favorable ways. When I am still and reflective, I always see the evidence of that postulate.

My mother's mother was born in Bermuda, but her family roots are patently international. Like so many Bermudians, her family represents peoples (nations) from different parts of the world. My mother's mother was born in Bermuda, but her family has roots in Morocco, Ireland, Portugal, Spain, and England. My mother's father was born in Barbados, and his lineage was Native American, African, and Welsh. From what I've been told by my mother and my aunt, my grandfather's mother was actually Egyptian. That was the African connection. Now, I don't know that for sure because that's a part of my family lineage that I have yet to follow up and research. This is simply an oral tradition passed on to me.

Both of your father's parents were Cuban?

Yes. When one says "Cuban," we are again dealing with an admixture of nationalities (peoples). My father's father was Portuguese primarily, with some Native American ancestry, which would probably have been Taíno, and then my father's mother was mixed as well, being: African, Native American, and Spanish.

When people used to ask me, "Well, what are you?" I used to say, "I'm the United Nations." I don't identify myself as "black", even though many people born in the U.S. of African descent and "mixed" ancestry generally do, but I do identify myself as someone of *African and African-American* ancestry. The reasons for this have to do with things I've learned about the problems of applying color designations to people, but my reasons also relate to the lessons of social and legal history, as well as revelations I've gleaned from psychology. Even growing up, I was not encouraged to simply identify as "black." I was encouraged by my elders, especially my mother, to identify myself by my nationalities. Then, if someone said, "Well, you know, the society sees you as African-American." I would say "Well, yes. But it is more complex than that," and that is a more complex discussion. For example, Egypt is in Africa, so, essentially, someone who's Egyptian is an African-American, yet an Egyptian will, generally speaking, not identify themselves as black. Why? I may not know what every individual Egyptian's reasons may be, but I have a pretty good

suspicion as to why that is generally true. I do, however, know what *my* reasons are, and it isn't that I don't see myself as related to people who are *classified* as "black." I do. I just don't use the term "black". That's something that people who've had an opportunity to read my work, or who have heard me explain in any of my classes or public lectures, know where I'm coming from.

Simply put, I often say that Asian Americans never identify themselves as "yellows" or "yellow-Americans," even though people in general sometimes use the color designation of "yellow" to talk about Asians, "red" to talk about Native Americans, "white" to reference Europe's descendants, and "black" for Africans, but most of the time those who are using the designation of "yellow" are not Asian themselves. Asians primarily identify as Asian, pure and simple. To get a sense of where I'm coming from, it's similar. I don't care for the use of color designations at all. I think that the use of "black" and "white" is particularly polarizing. We can see this when we hear the popular saying that something "is neither black nor white." It's like opposite - *oppositional*- ends of the human spectrum. I'm not trying to think of Humanity in those terms, so I'm not going to give any energy and any power to something that creates this idea that people of European descent are inherently and perpetually on this side of the Human family, and people of African descent are on that side.

They don't have to be. Whether one stands on one side or another is dependent upon that particular person's worldview, values, and actions. If a person's actions and values are demonstratively destructive, then that's different, but, just being European or being African should not automatically put them on opposite sides of the proverbial spectrum.

There was a young man who made a comment at a public lecture the other day. He identified himself as "black," and he said that his girlfriend was "white." Remember, these are the terms he used. The way he framed it, he said, you know, he said, "I'm black, but my girlfriend is the opposite race." His language was very telling. "The opposite race," he said. Psychologically, he was affirming this notion of opposites, as opposed to variations within the Human family. I see it as a holdover from a very destructive time in American history in particular, but in Western history in general – a time when people were conditioned to think in those terms. Persons of African descent within the Western world were typically classified either as non-human or subhuman, and therefore placed completely outside the realm of the Human experience. This is something which relates to the work of men like France's Jean-Paul Sartre who talked about the notion of "other" when it came to European relations with African and Asian peoples.

If we are "of one blood," as even the creed of our college asserts, referencing Acts from the Bible, then clearly there is no such thing as an "opposite" race. There are, from my perspective, only families within the Human race, so I choose not to contribute to such obfuscation, confusion, and division by talking about "black" and "white" races, and I certainly don't use the term "yellow." I chose to speak of people as being of African, Asian, Native American, or European descent, or combinations of these branches of Humanity. Very occasionally, out of expedience, or out of respect for another person's right to use such terms, do I find myself applying color labels to folks. I respect the right of others to use them, but I don't.

[Answer to main question]:

I think one of the key aspects of who I've tried to be is someone who, every day, improves upon some aspect of myself. I've always looked at my own life and life in general, as school. Interestingly enough, when you provided those two questions, and the first question about whether I have any regrets or wish I did something differently, there was a time when I did sometimes think that I had made several errors along the way, but that stopped as I started to look at every

experience as another act towards perfection, to the extent that I'm better than I was before.

It kind of goes back to a philosophical – or theological – perspective that Dr. King had, which was that he thought that the human being was perfectible, to the extent that we were able to become more loving, more truthful, and more peaceful. Of course, the paradigm or the model for Dr. King was Jesus the Christ or the Nazarene, a particularly important religious and/or spiritual figure for billions of people.

My maternal uncle was a huge influence upon me, and it was from my conversations with him that I came to view the world in that way. My uncle was actually more influential than my Dad. I was born to a family who, on my father's side, had only been here for that first generation. My father was the only one here, with the exception of a half-brother. Essentially, he was it. My father immigrated to the United States from Cuba. He was born in Cuba. My mother and her siblings were the first generation "Americans" born here. I think having that immigrant background so close made me more aware of the diversity of experiences. After all, my own family was a perfect example. With this also came a greater awareness of the challenges that diverse peoples were facing as members of particular ethnic groups within the United States.

My uncle was very big on getting me to understand the value of who I was as a person, and in particular, my value as a

person of African ancestry. There was no question, essentially, given the dominant societal view, about the value of European descent, so my family connections to Wales, as well as to Ireland, and Spain, and Portugal, were not associations which generally caused those of us in the U.S. to question our so-called "racial" value or societal worth. My uncle emphasized my need to better understand and embrace our familial connections to our African roots – Morocco in particular – and that didn't just include her present borders, but those which extended beyond the present day country of Morocco. Last and not least, I needed to better understand and reconcile my Native American ancestry. Initially, I didn't know a whole lot about it – given what my mother, or family told me. This was something I would discover later, because I took an interest in who we were as a family and the issue of identity. Everything for me, then, was part of the lessons of this proverbial "school" of life.

You're in college at Berea, and you know what it is to be in an academic environment where you're challenged in different classes, and some professors may challenge you more in certain areas. You also have various experiences interacting with other students. Each one of those things is a learning experience. Some of them can be more difficult than others, but, ultimately, everything is helping to shape you into a new person, with every minute and every hour and every day that

passes. If you're conscious of it all, as I was around my early '20s, then greater self-knowledge and awareness emerges. This was how and when I started thinking more deeply, for sure. Once you do that, regret begins to fade. You begin to say, "Every experience I'm having is making me a better person. I learn from that lesson, and then I move on."

We may have periods when we feel sorry for ourselves, and other periods where we lose our own sense of purpose at a given point in time, and as I say, lose our way. If we slow down long enough and reflect, then the reality comes back around, and that reality – *my* reality anyway – is that every experience that I'm having is making me a better person. I'm committed to that end.

I mentioned earlier my uncle's influence, and my uncle was part of – essentially a Moorish Sufi tradition, known as "Moorish Science." It's associated with a *Marabout* tradition, and is usually considered the more mystical side of Islam, but it's also a side of Islam which puts greater emphasis upon the kind of prescription given by Isa, or Jesus, which was that all of us, all women and men, have within us the ability to perfect ourselves if we commit to that proverbial Holy Spirit, or that Holy Breath or divinity within us. It's a belief that is not dominant, certainly, within the Western Christian tradition today. I talk about that, of course, to some extent, in my classes, particularly the course I teach on understandings of

Christianity, but it's certainly something born-out by history, and that is whether you're looking at the Gnostics, or whether you're looking at the Essenes. These were communities that had put greater emphasis upon activating or engaging the divinity within themselves, yet even in the Christian mainstream, or "traditional" Christian teachings, one can find that Jesus said to His followers, "These things and more can you do." They were amazed by His miracles and His wisdom, yet He told them that. He also said, "Know ye not that ye are gods?" He was trying to tell us that we have the ability to be like Him. By being more loving, truthful, peaceful, free, and just, we would be manifesting ideals associated with "God." God is supposed to be the epitome of all those things, and for me, because I had that influence from my uncle, it allowed me to look at things differently; even the challenges that I had, I take from them a lesson. What was the lesson in this or that? You know? I try to be as considerate of others as possible.

It reminds me of the physician's oath, "First, do no harm," and I've adopted that as part of a personal philosophy as well. If I was to look at other examples from ancient Egypt, also known as Kemet, there's this recognition that each of us, again, are seeking to become what the ancient Kemites called the *Geru Maa*, or the self-perfected man or woman. This too is based upon this idea of self-reflection and, of course, *Know Thyself*. These are things that had an influence on shaping me.

Much – if not most – of my understanding was seeded by conversations with my uncle, he was an avid reader and deep thinker. He did not attend college, but he was clearly one of the wisest people I've ever known. He also was a gifted artist, and so I saw his artistic ability reflected in music, in playing guitar and singing. His paintings were incredible. He also served with the Tuskegee Airmen during World War II, not as a pilot, but as a mechanic. His experiences in the United States were passed on to me as well, and then I took that with the bigger picture and started to formulate, essentially, who I was and what I intended to do with my life.

When I think about one of the things that used to bother me most, in terms of regret, I think about some of my previous relationships, especially my ex-wife. Now I am able to place it more comfortably into the category of Divine Order. I had been married in the early '90s to a lovely woman, who wanted, essentially, what a lot of people want, which is to settle down and have a family. We were married and I felt, at that time, that because of this larger purpose, or mission, of assisting the world in understanding the Africans' contribution to Humanity, something which I felt strongly about, that family life would largely be a distraction. My work, I firmly believed, would require me to travel extensively, which I did, and to spend long hours in dedication to scholarly work – all of which meant that a relationship was going to be difficult. I didn't put the kind of

attention and energy into our relationship, and as a result, we did drift, and we ended up divorcing. One of my greatest regrets was that we did not stay together, and have children.

At times, I would see other people with their children, and say to myself, "Well, I would love to have been able to, at this point in time, be talking about my daughter, or my son going off to college," but then, I also forgot that, in a very real way, every time I received emails, phone calls, and letters from exceedingly grateful former students who I'd taught over the last twenty years, they were basically saying, in no uncertain terms, "You were as a father to me." I started to realize that I had actually replicated myself in many ways through all of these students and even acquaintances who'd attended a public lecture I'd given. These people were essentially family members whose lives I'd really impacted in life-changing positive ways by what I had taught and shared with them.

I've come to realize what we often, as human beings, are aspiring to do when we have children; we're aspiring to be immortal in a very tangible way. We are seeking to be immortalized through our offspring. The fact is our offspring are not simply those who are of our blood, but those who carry similar, or identical perhaps, values which they saw in us and took to heart. Those who say, "This person, essentially, was like a father to me." That put it into a more positive and spiritual perspective for me. I said, "That was my purpose."

I know the type of person I am. I've also concluded that children of my own may have distracted from my mission. You see, I tend to dote on those whom I love, and I can only imagine how much I would have doted on my children, and it would have resulted in me not giving enough attention to what I felt I was really born to do, which was to, as I pointed out, really give the proper attention to African peoples, and in contributing ultimately to an increased historical and cultural awareness amongst the entire Human family. The good news is, of course, there's still time if it is my destiny, if it's what I'm supposed to do. If it's part of Divine Order, I will have children of my own, but if I don't, that's OK, too. I realize that, a lot of times, we want something purely for ego-based reasons, and not necessarily because it fits in with our greater purpose.

I remember hearing early on that Gandhi didn't have the greatest relationship with his children – it might have been when I was in my twenties. So much of Gandhi's situation was, again, because he was giving so much to the world. I don't mean to put myself on the same level in terms of present impact upon the world that Gandhi had, but I do know that to some lesser measure, I've certainly had a significant impact in dismantling the negative image of the African world within history and scholarship. Just based upon what I've witnessed over the years – the countless numbers of people who have contacted me who I never expected to be contacted by,

including scholars and celebrities, who've found out about the work that I've done, and asked me to share with them, and so forth, but individuals like a Gandhi, or even Dr. King, at times found it difficult to be "good" fathers because they were being tugged on by so much more than just their own families. What was once an unquestioned regret, is no longer as regrettable. I have now found much more peace and contentment with where I'm presently at, and with who I am.

❁ ✿ ❀

David "Boots" Humphrey was born on June 14th, 1952 in Alexandria, Virginia. His mother, Wanda Humphrey, helped everybody. Whatever somebody needed to be done, she'd do it. To make money, she sold Avon and she fought for senior citizens' rights. She was a hard worker. His father, Floyd Humphrey, was a coal miner. He got hurt, and then he wasn't able to work, so David's mother had to make money for the family. To make a living, David has been a mechanic, has worked at ski resorts, and has dug graves. He enjoys riding motorcycles.
Taped interview. December 28, 2012.

When I was in my twenties, I partied too much, drank too much, 'cause that was all there was to do here. I worked, drank, and partied. I'd probably still be partying now, if I wasn't on

probation. To an extent, anyway. I wouldn't drink, but I'd be smokin', anyway, and I don't think there's anything wrong with that. I don't think I had anything I really wished I would have done different. I liked me the way I was. I don't like me the way I am now. That's the way the feds made me. The prison system made me the way I am now. I don't have much respect for their law. I think their law is for them. It ain't for me. It ain't for nobody that I know, but if it benefits them, it's their law, you know? Now, don't get me wrong. There's people in prison that should be in prison. There's people in prison that shouldn't be there, too. There's a lot of people there that have killed people and robbed people and did whatever they did. A lot of people are in there for possession of weed, or their favorite choice of drug, or whatever.

Then, you got the Mexicans here, you know? They're deporting them because they're saying they're illegals. I say, "Well, I always thought this country was supposed to be a free country. Who cares why they come here? They're here working and doing the same thing we're doing." If I went to Mexico, I could go do it there, up until here recently. I understand the cartels are killing a lot of Americans down there, so it may not be good for me to go down there now, but I guess in some places it's still safe. I've never been there, but I'd like to go check it out. I'd like to go where the mountains is.

I had some good friends in prison, or acquaintances, more or less. You don't have very many friends there, 'cause they're not there long enough. He might be your friend right now while he's there, but he might leave tomorrow, or he might die, or you might leave tomorrow. See, you don't try to get attached to too much of anything in there. Just go in and do your time and get out of there. But, sometimes people don't give you that choice. Then you've got to take the matter in your own hands.

I quit about the ninth grade, something like that. I think I had ninth grade, tenth grade subjects. I quit and went in the Army, for four years. Actually, I first quit and went out in Ohio and worked in the oil fields, when I was young, like you was asking me. I worked in the oil fields up there. Old milk truck, hauled 55 – 50 gallon barrels of water and used it to prime the wells, and used it to drill with, too, keep from burning up the bits. They used the water out of my truck to wash the grease and stuff off some of the rigs and they used it for a lot of things. I made good money.

I had a teacher one time. I asked the principal to trade my 1:00 study hall to 3:00, and my 3:00 history class to 1:00. He told me, "Aw, don't worry about it. You only got two more weeks and it will be mid-semester." And he'd change it then. I was working for the MP store down here in town at the time. So, I was cleaning floors and mopping floors and buffing, and everything else. I think I was making $3.10 an hour. That was a

lot of money back then. I had to go down there every day to find out whether I worked or not. Well, if I don't have to work, then I had to go back to school. *Supposed* to. Half the time, I was like, "I'm not going back to school. If I went down there, I'm not going back. At least not today."

But one day there, I decided I'd go back. Wasn't nothing going on. I think it was raining, or whatever. So, I slipped into class and sat down. Tried to be quiet. You can't be quiet in these classrooms. Through the door, all the kids was looking at you to see who was coming in the door. So, I went over and sat down in Carol Roy's class. Whatever subject she was on. They were three or four days ahead of me. I hadn't done nothing in three or four days, so I don't know where they're even at. She'd ask me a question, and I'd tell her, "Sorry, I don't know the answer to that," so she'd ask me another one. She asked me about three or four questions there in a row. I told her I was sorry, that I didn't know the answers to none of them. So after a minute, she got mad, and asked me, "Which do you think is more important? Your job, or my class?" I told her, "My job. I get paid three dollars and ten cents an hour. I sure don't get that to come in here and listen to you bitch at me." "You go to the principal's office." "No problem. See you later."

So, I went down and told the principal. He said, "What's up with that?" I said, "You told me you was gonna take care of that. She's up there, basically trying to dis me in front of the whole

class. She knew I didn't know the answers to it. Hell, everybody in there knew I didn't know the answers to it." He took care of it, but she still failed me. For them two weeks. I said, "Yeah, I see how well you took care of it."

In the Army, I ended up beating one of my CEOs up and got out of the Army for beating him up. He was a higher rank than me. He called my – she was my girlfriend at the time. She changed cars. She come to pick me up. I was in a real bad mood anyway that day. I was having a real bad day or something. Well, anyway, he asked me what kind of a whore I was running around with now. I was asking him, "What are you talking about?" "That whore out there," he says, "in that yellow Mustang." I remember her telling me a few days before that she was trading her '65 Mustang off for a '69 Yellow Mark 1 Mustang. I looked out. Sure enough, that's who it was. I hit him before I even thought about it. "You just called my old lady a whore!" I punched him right in the face and I rolled him. I rolled him right over the desk onto the floor on the other side of the desk. He come up off the floor. We was stockade guards. He told me he'd have me in the stockade that night as a prisoner instead of a guard and, "The hell, you say." I beat the crap out of him. I knocked him out. I left him laying there on the floor bleeding a lot. We went up and got in her Mustang. I went to the barracks and packed up my stuff. "I enlisted in your all's man's army, I'm quitting your all's man's army. I'm coming

the heck home." "You can't do that." "Watch me. See ya. What are you gonna do about it? You can send your cops after me, but I don't care if you send them or not." I ended up getting an Article 15 out of it about four months later before they could catch me. It's just a fine and a loss of rank and that I had to go back in the army again. I thought they was more of a joke than they was anything. I mean, they're not a joke. They protect our people, you know? But, I thought that what we were doing at the time was a joke.

I liked me the way I was, until they thought they was God. Why am I the way I am now? I don't really know how to explain that. Our government, they think they oughta control you. Just like right now.

Prison was a different experience. I don't wanna go there again, and I'm not going there again. I'll be dead in the ground before that happens. I'll make sure of that. I think that the judges and the lawyers and the prosecutors and all these highfalutin' people here that's got money, anybody that's got anything to do with the law here, I think they should have to do at least six months in a regional jail, and maybe another six months in a prison somewhere, before they can be a judge, or before they can be a lawyer. So, that gives them an experience of, "Ok, well, we don't need to put this guy away in prison because we know what that's like." But you all don't know jack about it.

My dad worked in the woods, in the CCC camps back in the day. He was a dynamite expert. He blew up tree stumps and rock ledges, and anything that got in the way of where they was putting a road at. I really don't remember a whole lot about that. I remember him telling me he blew up his boss' hobnail boots once. He died in '81, and I was born in '52. I was thirty some years old. I was working in Hilton Head, South Carolina when Dad died. I was down there working on the island, but I lived off the island. It cost too much money to live on the island. I come home for Dad's funeral, and never went back. What money I had when I come home, I give Mom to help pay off the funeral, or whatever she wanted to do with it. I didn't care.

I come home, and really got into partying then, after Dad died. I drank a lot of liquor then. That was every day. We bought enough liquor on Saturday to make sure we had liquor to party on Sunday with. I got to the place where I drank so much, it would make me sick for two or three days. So, I quit drinking and started smoking dope. For years and years, all I ever did was smoke. It don't make me sick, and I can work and do what I wanted to do and drive my car. I ain't ever heard of nobody dying from smoking weed. I heard of a lot of people dying from drinking, though. Or mixtures. But, not just from smoking weed. I don't think that's possible. I smoked a lot of it. I'd like to have all the money I put in weed. I'd probably have a

real nice mansion by now, and four or five trucks, and whatever the heck else I wanted, with what we put out in weed, but I never did need that crap.

I wouldn't be living in this trailer right here right now, I'd be living back in the camper, if it wasn't for the probation people, wanted me to be in a house here where there's a trailer and electric, and a bathroom and all that. I ain't never needed it before. I don't see why I need it now. "Well, you're getting older." Well, maybe. But I'm pretty sure I can still shit in the woods, or the outside house. I just think our federal government, they say they're doing this for the people. No, they're not. They're doing it for their way of life. They can talk all that crap they want. I don't believe none of that. I got to a place where I was sick and tired of being sick and tired. So, if I died today, it don't matter to me. I don't really have nothing out here. I mean, don't get me wrong. Sure, there's a lot of material stuff here, but that don't mean nothing to me.

The cops, when they was up there at my house, they wanted to know who owned all them motorcycles. "Well, now, fool, whose do you think they are? They're mine. They're sitting in front of my house, ain't they? I'm pretty sure they're mine. I'm sure somebody didn't just bring me motorcycles and leave them sit up here. I mean, it would be nice if they wanted to, but I don't see it happening." "Why do you got so many of them?" "Well, I don't think that was any of your business in the first

place," I said, "but I got them 'cause I could. I figured if I ever needed any money, I'd just sell one of them, then I'd have money." I ain't never did without. I've never starved. I'm not trying to starve myself. I've always learned how to survive on my own. Just another day in the life and times of Parsons, West Virginia.

I like living out in the woods. You get to hear the animals and hear the water run and the rain on the roof of the camper. You don't have people right there steadily going by your house, or steadily being there, period. It's private property. If you wanted to run around out there in the woods butt-ass naked, you could. Piss or poop off the porch, whatever you want to do. I mean, if you wanted to do that, you could. It's bad up there in the winter time though, where I lived in my camper before I was arrested. Snow'd drift in there a lot, but I still got in and out. I guess I'm sort of a modern-day mountain man. Some of the old mountain men, they'd go out there and be gone for months and months before they come to a city, and sometimes it would be months and months just trying to get to a city, back in the day. I'd kind of like to live back in the days. I think it should be like that now. I carry my gun, you carry yours.

In prison I watched a boy cut another guy's throat because he changed the TV on him three days in a row. This black man was never there. He'd be in school, he'd be out in the yard, he'd be wherever. I don't know exactly where he was at, but every

day, he'd come in, regardless of who was watching the TV, he'd just walk over and turn it. You could be three quarters of the way through the movie. He didn't care. He turned it. I guess he turned it twiced, and that white boy told him, "If you turn it again, you'll not do that no more." The other guy said, "You ain't gonna do nothing." He said, "Sure I will."

The third day, the boy come in, turned the TV on him again, and this white boy got right up and walked off and was gone for a few minutes. The black guy was sitting there watching TV. He just walks up behind him and cut his throat. Walked back over, turned the TV back to the station he wanted to watch, right back over and sat down on the chair and proceeded to watch TV again, the white boy did. That black boy sat there and bled to death. He was dead when he cut his throat. It was probably twenty minutes there before the cops even realized that boy was bleeding. I was amazed. I had never seen anything like that. That white boy who killed him, he was in there on multiple life sentences. He's gonna be there forever, and he's gonna die there.

So them people there, you didn't mess with them people. They tell you one thing, you'd best hear what they're telling you, 'cause they didn't have no problem trying to kill you. They'd already killed people. The government here ain't got nothing they can take from them, except their life, and a lot of them would rather be dead than be there, so if they took their

life, they'd feel a lot better, I guess. You don't have to put up with the government, you don't have to put up with their rules and regulations no more.

Life and times of Tucker County, I guess. And everywhere else, you know?

I don't think this Parsons here, this town, will ever be the same to me. Nothing in my life will be. Your time's done in prison, but they still want to control you for three more years. So, I got two more years of putting up with their crap here. Can't smoke no dope. You can't do this. If I wanna go somewhere, I gotta call my probation officer. I ain't never been like that. I get ready to go, I'm just gonna go out, get in my car, and go, whatever it comes to, you know? But if you wanna stay out of jail, stay out of trouble, you gotta do what they want you to do. But after a while, it just gets to be like a game. You get tired of dealing with all of it.

So, just another day here.

Denice Reese *was born in 1956 in Salem, Ohio. Her mother worked as a homemaker and bookkeeper, and her father worked as a cost accountant. She is married to John Warner. She is a pediatric nurse and worked in a pediatric emergency room and as a school nurse. Currently, she teaches nursing students at*

Davis & Elkins College in West Virginia. She enjoys dancing, playing piano, and singing. She is also interested in human development, especially as it relates to people figuring out how to thrive and be joyful in their hearts, their heads, their bodies, and their souls.

Taped interview with written edits and additions. January 6, 2013.

I am a really optimistic person. I love the word irrepressible, as in irrepressibly optimistic. So when I look back at something I would have done differently, I guess I would remember times when maybe I lost sight of that irrepressible optimism. Never for very long though, so maybe I can still claim irrepressible optimism. I have had an amazingly rich and fulfilling life – one I never could have imagined while growing up on a potato farm in Ohio. I sometimes feel and felt that I get stuck in negative little vortexes of thought and behavior, and it can be self-perpetuating. I look at various aspects of my life, and I can see that. It's a broad thing. It's not a specific thing. Sometimes, it sort of feels like inertia. Sometimes, it feels like fear. But, like I said, the other side of that whole thing is that I am an infinitely optimistic person, which is my salvation. My hope runs deep for both personal change and transformation, as well as for my having an influence on other people to change and transform. I believe in people. I like people, so, that is the thing I *don't*

regret: the optimism that I think people sense in me and I know is true; there is nothing more true in me than my optimism. My optimism and my love are intertwined in a way that you couldn't tease apart.

I guess I believe really, really strongly in change, in incremental change, and sometimes geologic change, you know, where something huge happens, and that's the watershed event, because that has happened to me. I guess you would call that a paradigm shift, you know? Where you just turn your head around a different way and you say, "Oh. I don't have to think of it that way." That has been a major thing, but, that having been said (that's the upside), I still get stuck. I get stuck in inertia and fear and everything from physical activity, which I am currently in a flurry of, because of family circumstances that make me realize my vulnerabilities and my genetic predisposition, and it made me think hard about how my lifestyle choices can affect my overall health, and the fact that my mom had a stroke recently.

And in relationships, I am very conflict-averse. I don't like confronting people, although I have had some very, very phenomenal experiences of telling a truth or confronting something that isn't right or isn't fair, and people looking and saying, "Oh." And it's either that they didn't realize it was a problem, or they didn't realize it bothered me, or they didn't realize how hurtful it was, or whatever. I should learn from

those more than I seem to have. I still have a great deal of fear in me of conflict and confrontation, to my detriment, and to the detriment of those I love.

Those times in my life when I've been really physically active, it gets my whole head in good shape, but I don't always learn from that. I can pretty easily get back to the inertia stage, so that's one regret. And eating well, which goes hand in hand. I have evidence in my own life of feeling better, being more energetic, being more positive (which I love) if I eat well and move a lot. Then, I get busy, because I am also very, very, very committed to my work and a lot of that is sedentary work, reading, working on the computer. I get lost in that.

I can think of situations in my life where I have lived with this low level of pain that doesn't rear its ugly head very often. The pebble in your shoe thing where, eventually, it hurts enough that you take your shoe off and you get rid of it. That's an idea I've thought a lot about, too. This tolerance of low-level pain, whether it's because I'm not physically active, or I'm not eating right, or there's tension in a relationship, but I can live with a low level of pain rather than confront it, and how detrimental that is. I have at times in my life been able to – what you might call – "create the conflict", where I say, "Ok, this is it. I'm sick of this. I'm tired of it, bring it to a head and let the chips fall where they may." It's actually been usually a very good thing, especially if I do it calmly! There are other times

when I just don't go there. Either I move far away from the person and I never resolve it, or there is a period of tension, usually followed by resolution. I'm still pretty conflict averse. I wish I weren't as afraid of that.

I'm not as afraid of having an opinion as I used to be. That's one thing I've grown in. It's not that I'm rude, but I'm not as afraid of expressing an opinion, or that if something is less that positive, less than helpful, less than growth-producing, that maybe we should fix it. That's an ongoing struggle. Wherever that came from in my life, I don't necessarily know.

Some of my most happy recent discoveries are positive psychology and something called Appreciative Inquiry. Such hopeful good stuff that builds on strengths rather than focusing on fixing deficits. It is really pretty neat to find ways of thinking that you did not know about, but that somehow are all aligned with your own evolution as a person. I feel stronger and more empowered all the time. Empowered to do what – who knows – to be kind and helpful and maybe a model of how to live that irrepressible optimism.

I also wish that I had better relationships with my mom and my dad. My mom is a good person who has been generous and helpful in my life, who has loved me beyond the eternity of mothers' love, and my dad the same. Just loved me to bits. It wasn't until he was dying that we really resolved our conflicts, which I guess is not uncommon, but you would hope that it

would come long before that. I said one prayer when my dad was dying – and I was caring for him – that was, "Please let me do this with kindness", and I said it over, and over, and over again. Nothing was ever so easy in my life than taking care of him while he was dying. There had been a lot of head-butting conflict in our relationship. It all just melted away.

Maybe that's the theme. That insecure ego rearing its ugly head and getting in the way, you know, that fearful "don't challenge me" ego getting in the way. I wish I had learned that long, long ago. It would've really changed my life. It still is a problem now in certain situations. Less so in a lot. I can really let that ego sit back and take a back seat to my real sincere self, my sincere soul. I try to not react to stuff very much. I try hard because I recognize that reaction as me defending some petty fear in me, some tender little spot that I can't let anybody hurt. It took me a long time to learn that. Being quiet and not reacting are still not consistent behaviors on my part. I still rear up and protect a tender little child inside me sometimes.

I confront, but I confront not as an attack, but as a telling of the truth or telling of a perception. I do it in a way that is not meant to hurt or to put the other person on the defensive. I try to make a safe place for people to come to a conclusion that will allow them and us to be at a more peaceful and productive place. It works, generally, and that makes me hopeful.

One of the things I've learned is that somebody's bad behavior, whether it's their anger or hurtfulness or whatever, is usually a manifestation of some type of fear or insecurity in the other person. What I've learned is that if you can sit safely in that – that is, make a safe place for that person – without reacting, that oftentimes, it's like it turns the heat down on the stove. Their bad behavior is about fear – the same fear that would cause me to react with my own version of bad behavior or defensiveness – and if you make a safe place, then you can just talk. That has happened again and again in my life, and I'm so very, very grateful for that realization.

Thank you for the opportunity to think about this. I can tell you that that question is the kind of thing that could result in somebody doing some good examination of their life, today and into the future. The only thing that we have is right now. It's all we have. Yesterday, dwelling on it is a waste, and tomorrow, we don't know what's going to happen anyway. So, do it now, and love. And don't be afraid. Don't be afraid.

Nancy Gift was born in 1971 in Lexington, Kentucky. She is a professor of sustainability at Berea College. Previously, she taught sustainability and environmental studies at Chatham University in Pittsburgh for 7 years and before that, she taught

part time at the University of Chicago. At Cornell University, she had a collection of random jobs, such as forestry at the Cornell orchards, work in epidemiology at the vet school, and Ag Extension. She enjoys hiking and any sort of non-motorized transportation, like horse-back riding, biking, and kayaking. She likes seeing the world from the different perspectives that these modes of transportation offer. She has two children and she loves watching what they do. Her sister is twelve years older than her and is schizophrenic. Even though she was a younger child, Nancy has always been the more responsible, functional sibling. Her parents' names are Richard and Becky Gift. Her dad was a professor of economics at the University of Kentucky. Her mother was a housewife and an artist.
Taped interview. January 16, 2013.

I went to Harvard, and I was always really focused on long-term goals. So I knew I wanted to get married and have kids, and I knew I probably wanted to go to grad school and get a PhD, and maybe be a professor, because I really liked my dad's job. He sort of had the right combination of interacting with people and getting to think on your own, so I was really focused on those goals, and I kind of missed –

There was a point when I was just finishing college when I heard so many students saying, "Well, I don't know what I want to do next," and I took a really safe route of going and getting a

master's degree, and it worked out fine, and a lot of good things came out of that, but I've often wished that at that point, I'd taken some time to travel and to be lost a little bit. I find myself kind of reliving that decision often when I'm advising students, because if they say, "I don't know what I want to do next," and they feel really worried about that, I'm always trying to reassure them, like, "It's OK. You can take a year or two. You can go travel."

We got married when I was 24. We were both 24, and then we waited a while to have kids, but it just felt like at that point, that all decisions were together. The flippancy of maybe going off to Australia or something like that, it was never going to happen, because I was so long-term goal focused. I wish I had been more open to exploring at that point.

That's really the big one. So, I don't know if that means we would have married later, or what, but it just feels like there is a lot of space that – now, I have to wait until my kids are grown to go play like that, and that just feels like a long time to wait.

Can you think of any specific things you wish you could have done?

Travel is really high on the list. I think I would have liked to do more of those short-term jobs with my hands, for example, trail work, walking the Appalachian trail, working for a

National Park. I would like to think I'd have been more open to some short term jobs like a seasonal job somewhere cool – the Everglades or something like that – and just go be in that space for a while. Yeah, I'd be lonely and uncomfortable in some ways, but what I find now is that the stories of the adventures I did have, even if they were kind of quirky, like working at the Cornell research forest, I really get a lot of pleasure from those memories, and it would be neat to have a bigger stock of them.

How do you think having some of those experiences would have changed who you are now, or what you do now?

Well, that's kind of hard. I like to think in a lot of ways, I would have ended up in the same place, because I like to think that I don't take myself too incredibly seriously, and that's one of the risks of the way I did things, was that I just went straight through grad school, and I took life very seriously.

But, I think one of the things that would've helped, is I would have met more varied and interesting people. Sometimes I feel like, when we lived in Pittsburgh, for example, I felt like my circle of people was pretty small. I'm not really outgoing, so meeting new people always scares me, and I think that was part of the fear of doing a job – or doing that sort of travel. Once I get to know someone a little, I find that I'm happy to have gotten to know them. And then I can share my stock of

stories: "Oh, well, if you're interested in doing that, then I could put you in touch with so and so."

So, to some extent, it's kind of weird to say – it would help more with advising, and it would help more with helping students connect, because I would know more people in more different places who did funky and interesting things. I guess one thing I find frustrating in my advising process, or in working with students, is that all I know is academia, yet students are looking for what they want to do next. I don't really know what there is to do next, because I didn't do much of it. I'd love to have a bigger stock of like, "Here are the various professions," and even if I only saw them as, like, a temp person, I'd have loved to have seen what they were like so I could communicate about them to someone who hadn't yet seen the world – and who needed to know where they could go next.

I wouldn't want to be in a different position than I am now, but I'd like to have more stories and experience to do this job with. And maybe more stories for my kids, but your kids never want to hear your stories. It's other people who want to hear them. It's not like a "big evil regret" kind of thing, but it's one of these things that I feel like I'm going to have to work extra hard to fix later because I didn't get to do that.

Dave Porter *was born in Berea, Kentucky, attended high school in southern California, and became a helicopter pilot and behavioral sciences teacher at the Air Force Academy. Retiring with 34 years of commissioned service, he returned to Berea College as Academic Vice President and Provost in 2001. After four years, he returned to the classroom and has been happily teaching courses in psychology and general studies ever since. Submitted in written form.*

I am a 20 year old cadet at the USAF Academy. It is summer and I will be serving as a member of the group of upper class cadets training new cadets during basic cadet training (BCT). A friend of mine, an ex-football player nicknamed Conan, the Barbarian, has asked me to join his unit. K-Squadron is the retraining and re-motivation squadron. It is important that none of the basics be allowed to quit or drop out of the training until the grueling summer is complete. K-Squadron is designed to be a unit so feared that no one would even think of asking to drop out of regular basic training because they might end up in the clutches of the K-Squadron cadre. Why not? This sounded like fun.

The first basic to decide to drop out did so before his administrating processing was complete. He claimed that he just wasn't a good fit for the military – before he had even glimpsed what he was in for. Within 24 hours, he was in K-

Squadron and my buddy, Conan, assigned him to me as a special project. I was supposed to make an example of "Johnny". But I was an enlightened and progressive kind of guy, and belittling, berating, or bullying someone just wasn't my style. I had complete control and could do what I wanted with Johnny. I decided to use operant conditioning. Johnny was basically in solitary confinement until, and unless, I said otherwise. He had a book full of tasks he was supposed to master and long quotations and century series aircraft he was supposed to commit to memory. I would visit his room regularly and just ask what he had to show me. If he had done nothing, I would simply leave. It wasn't long before he started doing the things that needed to be done. The reward was acknowledgment of his accomplishment and the opportunity to talk for a few minutes. Johnny quickly learned that performance was the key, and he was soon ready to be integrated into his normal training unit.

As it turned out, Johnny was an exceptionally capable and highly motivated basic cadet. His shoes were the shiniest shoes, his recitation of knowledge the most accurate and complete, and his time on the obstacle course the best in his squadron. Everyone was so impressed with what "I" had done that I was even invited to the commandant's daily briefing and congratulated publically.

I was involved in retraining and re-motivating half a dozen other basic cadets over the next few weeks, but none responded quite as well or quite as completely as Johnny. Shortly before the first phase of BCT was to end, I learned that Johnny was, in fact, being out-processed. As it turned out, he had taken an entire bottle of aspirin in an attempt to commit suicide. He had to have his stomach pumped, but his action convinced the powers that be that he really was not a good fit for the military.

The realization of what I had almost done dawned on me slowly. I realized that I had used my power and knowledge to manipulate Johnny. I had imposed my will (based upon my need to look good) on another. Although I had not physically abused or mistreated or even raised my voice, I had taken away his dignity and replaced it with my own agenda. I was ashamed and embarrassed. The next week was one of the worst of my life. What made it all the worse is that no one else seemed to notice or care. The few friends I confided in quickly encouraged me to shake it off and forget about it, because Johnny was clearly fucked up from the git-go and there was nothing I did that really mattered.

Unfortunately, I knew better, and I knew that I could do better. It still haunts me that I could have been so callous and self-serving. Although this started out being a story of something I wished I had done differently, it has turned out to

be a story of an incident about a very bad mistake I made that still serves as a reminder of the importance to treat others with respect, and not to abuse the power I have.

❀ ❀ ❀

Caroline Barbara Carr-Starr *was born in 1960 in Birmingham, England. She currently manages rental property, does construction and remodeling, and she accompanies Dusk Weaver as a musician. She has made money in many different ways throughout her life. She has been a grant writer, and a land developer. She has managed properties, cleaned houses, taken care of autistic youth, helped handicapped people, driven a school bus, and been a teacher's assistant. Founding an intentional community, building a passive solar home, and parenting have all been important aspects of her life. She enjoys gardening, homesteading, raising goats, reading poetry, mystical explorations, herbal studies, learning about indigenous cultures, and hiking. She has a son named Tristan.*
Taped interview. December 23, 2012.

I had a lot of adventures in my 20s and 30s, but I think something that changed the course of my life and awakened certain interests was the decision to study herbal medicine when I was finishing up university at Rutgers. I had always had

an interest in the outdoors and nature, and when I was in school, I really enjoyed the anthropology classes I took. I was exposed to ideas about indigenous cultures and their use of herbal medicines, so I was curious about it.

I apprenticed with David Winston, a well-known herbalist who studied both Chinese and Native American herbal medicine. He had a business importing and distributing Chinese medicinals in the USA. Having studied with some Native American elders, he had a certain approach to the plant world, which really was an eye-opener that changed my view of things. He was teaching not only the healing properties, including some of the chemical constituents, the herbal combinations, and what the active ingredients were and why they worked, but also how to make tinctures and how to prepare herbal teas and oil presses. The way he approached gathering the native plants was from the indigenous perspective: that the plants were sacred and they were living beings, and you respected and honored them, and you don't over-harvest – you just take what you need. It was a whole approach with a philosophy behind it.

It wasn't anything like hard science. Having done some cultural anthropology at university, I could grasp the concept and appreciate a different worldview. In the youth of my 20s, I had more of an open mind, which I think is a beautiful thing – you haven't judged how everything works yet, and you're open

to different possibilities, so you're exploring more. You don't narrow your worldview as much. In anthropology, I had come across the idea that different cultures had healing methods that were totally different from Western allopathic medicine, from blowing evil spirits out of the organs, to opening up the energy meridians, to plants having spirits and devas.

One thing that was interesting to me, too, was that a lot of these remedies, in order to work, were often quite complex. It's not just a matter of harvesting a certain root of a plant or a leaf or the bark (or whatever it would be), but in order for it to be safe and efficacious, you would have to boil it or mash it, and if you didn't go through those steps, it might be poisonous or dangerous. So, I wondered, "Wow. Could all that be trial and error? How could they find all that out without a lot of problems?" It seemed amazing to me that they had discovered so many efficacious remedies.

The thing that really opened my eyes was when we went to gather some plant medicine. The Native American teaching that David shared was that you go with respect, you'd offer a prayer and a little pinch of tobacco, and you'd ask the plant permission the gather it as if it had a soul or it was a conscious, sentient being, and you'd wait for an answer. You don't just convince yourself. There were five of us students and there was the teacher. In all sincerity they were doing this. I was the

newcomer. I was the newest student and it was a two-year apprenticeship.

We went out into the woods to collect some specimens, and they were explaining how they did it. We were told to ask permission to gather the plant – these happened to be bayberry bushes – and we were asked to offer a little tobacco prayer and just to sit with an open mind. So, I just thought, "Well, I'll open my mind up and not judge, and see what happens." Yet part of me was still skeptical. David said, "If you're drawn to one of the plants, just follow your intuition. You might see a color or you might get a feeling." So, he didn't label it in any way. Finally, he asked, "Which plants were you drawn to?" I said, "Well, I'm not that naïve. I'm not going to tell you first, and then you'll all pretend to get the same one." Being that there were five of us, I was just amazed that the other four pointed to the same two plants that I had kind of felt drawn to like a magnet, because I had an open mind and I wasn't judging. I had settled on two plants. This was after about fifteen minutes of sitting. I was just really blown away. First one, and then another, then another of my company described the same two plants I myself had chosen.

Then, I had the dilemma of, "Well, what does that mean? Do plants actually communicate to humans, or, equally amazing, are we all telepathic and we're just picking up each other's thoughts?" Is there, perhaps, a higher intelligence coming

through our shared interaction? A whole new world opened up that there was some kind of interconnectedness, whether it was between people and plants or just people – that there was some kind of exchange of information happening on another level.

It began to make more sense when we did exercises where we might sit and meditate with the plant. I remember communing with a plant I wasn't familiar with, and what came into my mind at the time was a picture of the brain and the spine, and that one turned out the be the Skullcap which can help with the nervous system. I began the think, "Well, perhaps the indigenous people who are much more skilled and used to this would use their intuition and have these insights and guidance into how to use plants, so then there would be less trial and error." I'd now discovered a new faculty that I'd never explored before that was not taught in the schools, and it was pretty amazing.

I wouldn't go out and experiment on a magic mushroom. I wouldn't want to experiment really risky things or anything like that, but I really did find the guidance consistently worked well whenever I got a clear picture in my mind. So, I started to open my eyes to having more wonder and more awe about the natural world. And just, *wow*, you know? They're sentient beings. Everything's alive and has some kind of consciousness to it. I couldn't necessarily explain it, but it was more, not just

magical, but amazing to me. So, I was awakened, in a way, to appreciate nature even on a different level than I had before. I always thought it was beautiful and wonderful.

And then, after a while, I read *The Secret Life of Plants*, which is a book that influenced me and others. I learned about places like Findhorn and other groups that also saw that there was another dimension to vegetables and plants and that there's a communication that can take place and it's pretty magical.

It's a little sad, in a way, that I've lost some of that awe that I carried for many, many years, but I think it lead me to pursue other similar interests that I wouldn't have probably explored otherwise. I would have been more practical. It led me to have even more fascination with indigenous teachings, to respect them more, and to want to learn more about them, and to consider other cultural viewpoints and the psychology of everything – the psychology of healing, in particular. The Chinese system of medicine is thousands of years old and it's just as effective for patients. It has a lot to do with your belief system and more to do with what you expect and what you believe, you know, the placebo effect, than it necessarily does with what chemicals are in the medicine.

I think it has on many levels affected the way I see the world. I think if I had been too cynical, or not really dared to imagine that it could happen, maybe my mind would have been blocked off from ever receiving any information, if I hadn't opened

myself up to that possibility. Then, of course, it would have been a self-fulfilling prophecy, "Oh, well that's a load of rubbish." I think it has caused me to have an interest in green things and to have an appreciation for the natural world that I've carried with me. That unique experience helped to shape the person I am today.

Bill King was born in 1965 in Lancaster, South Carolina. His parents' names are Mary Beth Evans King and George Thomas King, Jr. Bill teaches Composition, Creative Writing and American Literature at Davis & Elkins College in Elkins, West Virginia. He enjoys writing poetry, reading, fishing, hiking, and building things with his hands. His wife's name is Beth Ruppersburg King. His children's names are Walter, 14, and Elizabeth, 21.

Taped interview. December 26, 2012.

Almost my entire twenties, I was in graduate school. I married young, when I was twenty-two or three, the summer after four years of undergraduate school, so my focus, as far as my life, was very concentrated on personal things. On the one hand, in my twenties I was very unsure about what to do with my life. I wasn't really focused on any one thing in the world

that was bothering me that I thought, "Oh, I need to go solve this problem," or, "I need to go join the Peace Corps," or, "I need to go pursue this line of work or this line of volunteerism." Partially, that was because, looking back on it historically, we were in a period where there wasn't a whole lot going on in the world as far as – America wasn't in a war yet. Although, in 1991 we would be in Gulf War I, which is something I'm going to get around to in a second. And I also was a little more – not narrow-minded (I've always been open-minded) – but myopic in my thinking.

In other words, like I said, I was more focused on my new family, and because I wasn't sure of what I wanted to do with myself, I just decided I would go to graduate school and that I would figure it out later. In fact, I had a degree in journalism and I was going to be an advertising copywriter, but that wasn't very fulfilling creatively, so I decided I would get a master's in creative writing. Then, my daughter was born in 1990, so my focus was still on providing for my family. All this context, for me at least, is going somewhere.

So, I started to think about how I was going to support my daughter. I thought, "Oh, well I'm not going to write poetry and sell it on the street." Everybody knows that all art forms are hard to sell, but poetry is one of the hardest to sell. So, I decided to get my doctorate in literature. I didn't then know I wanted to teach – I had just started teaching as an apprentice

the year I applied to the doctoral program. All I knew was that this would buy me a little more time and that I would continue to be able to support my daughter. My wife had just gotten a job teaching art. I still didn't know what action in my life other than that would be important. I didn't know what I wanted to do with my life.

I do think, to answer your question – this isn't where I started in my brain when I started – but I do think that my decision to teach, which really wasn't a decision (I didn't have a light come on) – it's just that after I had taught composition for two or three years, halfway through the grad program, I figured out that not only was I pretty good at it, but I felt good about what I was doing. I felt, "This is something I can do that doesn't just support me but provides something important to other people."

At the University of Georgia, I had such a wide variety of students, from gifted students to others who just could hardly speak, much less write English very clearly. I got a lot of joy out of having students really improve their writing. It wasn't just their writing, but I truly felt like their critical thinking skills were better and that they were walking out into the world better able to defend themselves, that they were somehow better equipped to not only provide themselves some joy in life, but for other people as well.

I would say a simple answer to your questions is that one thing I did in my twenties was to figure out that something I had always thought of as somewhat private, and maybe even a selfish thing, which was my love of reading and writing, which would often take me apart from people – you know, to go sit in a corner and read a book, or go climb a tree and write a poem – that type of thing actually became something I could give to the world. I still cannot imagine myself doing anything other than being a teacher. If I went back and thought, "Would I have liked to have been a newspaper man?" Or, "Would I have liked to have been a carpenter?" – there are lots of things I think I could have done with my life, but I can't imagine feeling any more fulfilled with my decision – sticking with it and getting my degree and teaching while in graduate school and not stopping to shift again like I had done after I got my undergraduate degree.

Teaching is a simple answer to your question. I'm glad that's something I decided to do. I decided to go to graduate school and not wait and just take whatever job that came down the path. If I had done that, I would have gone off somewhere else, and I am pretty sure I wouldn't have enjoyed it as much or felt as fulfilled.

A more complicated answer to your question is that something did happen that I kind of wish I had taken more action, but I really didn't know what to do at the time. That was

when I was in graduate school in 1991. I was in the second year of my doctoral program (my master's in creative writing was '88 to '90 and then '90 to '95 for my doctorate) Gulf War I started, and I can remember a friend of mine who ended up teaching English as a second language in Poland (he was a big guy, like six feet seven or eight, always wore Converse tennis shoes but never played basketball – he ended up getting married in Poland and coming back to Atlanta) – I can remember he and I having a conversation. He was in a class with me, and the day it happened how indignant we were that we should have started bombing Iraq on pretense, without a whole lot of run-up or discussion, which seemed to happen again later, but I won't get into that. At the time, we were like, "Well, what do we do with all this anger?"

I can remember going home, and this was the first war where you could watch bombs being dropped out of a plane, and you could see the bombs being dropped from x thousand miles above, and there was a camera mounted on the bombs, and you could watch them getting closer and closer to the ground, and then there's just this *poof*, like you're watching the Road Runner or something. Like the anvil being dropped off the cliff onto Wile E. Coyote and then there's just a little *poof* and you're way up above.

I remember, on the one hand, how if you said anything negative about the war that you were unpatriotic, and on the

other hand, how disgusted I was that there was all of this killing going on without so much as a conversation and without so much as understanding why. We had been given the reason, "Well, Saddam Hussein has used chemical weapons on the Kurds and he's getting ready to burst into Kuwait. He's getting ready to take over Kuwait, and we're going to save those people." But, I had all kinds of questions, like, "Well, there are 30 plus dictators in the world, and there have been mass killings all over the place, so why are we deciding that this is the one we are going to go in there and do something about and end up killing many more civilians, or at least as many as *they* have?" I had too many questions. I didn't do anything with that other than, I think, I wrote something about it at the time.

Now, one thing I realize I do now that I didn't do then is I had been taught to be very objective as a teacher, and also it had something to do with the classes I was teaching (it was composition and it was a set syllabus, so we had certain topics we could cover). We covered AIDS, and I was very happy that we were covering some sort of important social question, but it wasn't something I raised in class. I do know that the fact that I couldn't do anything, or I wouldn't do anything, other than talk to my friends about being pissed off did lead me (when I became a professor and Davis & Elkins College) to not be shy about raising questions about social issues with my students, and even working them into assignments if they chose to.

I'm very careful not to shove politics upon my students, but it's a natural thing that's part of our life. It's like not talking about sleeping or, you know, "What did you have for dinner last night?" I mean, to not say, "So, what do you think about the fact that we invaded Iraq today?" I do think that what led me to want to be more political when I'm teaching was to allow social questions. I know, for example, I've talked a lot about – and had as an option to students – to talk about mountaintop removal in West Virginia, because that's a big ongoing issue in West Virginia. Now that fracking is starting, it's almost like people have forgotten mountaintop removal. It's like, "Oh, now that we have two things happening that could be bad in the long run for the state and for the people..."

I do think that I spoke out about things, socially, that were an injustice, or were immoral. But, I was never one of those people to chain myself to a tree, or stand in front of a tank. My focus in my twenties was on my family. Family and school were tied up together because those things were going to take care of each other if I got my education. I think that desire for, and I don't want to sound "Pollyanna-ish", but for a better world through thinking more deliberately and acting on the convictions of your deliberation in the world, in your community, is something that I ended up infusing in my children. They speak out much more quickly and act a lot more forcefully that I did, sooner in their lives than I did.

Looking back on it, I wish I had acted a little more forcefully and spoken out more about the injustices that I saw, for example in Gulf War I. I do think that in the end, that's not something that haunts me so much, because not only do I feel like I have kids (they're 22 and 14 now) who are much more comfortable doing that and have proven already in their lives to be working within their communities and to be concerned with things other than just themselves and fulfilling their own desires, like I was when I was in my early twenties.

I don't really know if I should bring this in or not, and if it has anything to do with the question, but it's funny you should have come to ask me this question now, because since I was diagnosed with cancer November 7th (what is this – December 26th?), I've spent a lot of time thinking about my life and what I've done, or not done, with my life. I don't mean to sound morose, but I used to think I had all the time in the world to do what I wanted to do, not just for myself, but for other people. Although I am very confident that I have a lot longer, you can't help but think about those things.

I think these are very important questions you're asking. At times, you wish you'd figured out sooner, like the questions for the college-aged students, and in retrospect, I've done a pretty good job of trying to be aware. To me, that's the most important thing in the world, is just being aware of other people, living life fully, not just intellectually, but emotionally,

and being emotionally aware of what other people are thinking and feeling. If there were more of that in the world and less of the, not just geographical, but intellectual and emotional distance that I think the modern world encourages – like watching the bombs dropping from 30,000 feet and just going *poof*, as if there was no consequence for other people living somewhere else and their lives, and their families, and their children.

One of the strangest things that has happened is that someone said to me, "I don't think I would be that way if I had gotten sick like you," and I said, "Well, maybe you would. How would you know?" From the moment I was coherent after the surgery (which took a while, because I thought I was just getting my appendix out, and then they kept me down for an extra five hours – it took me fifteen days to get home from the hospital), I was never sad or angry about what had happened. For whatever reason, I was asking other people how they were doing or thanking them for their generosity to me, and I cried a lot, but I only cried because I felt this overwhelming joy that these people loved me and were trying to help me. I don't know quite what to do with that, other than to say – this has very little to do with your question, maybe – but it has always been there in me, and I think that people react differently, depending upon the ground that has been tilled in their lives and how they've lived their life.

That sort of – I don't know whether to call it a revelation, or just an experience – of opening up more fully to people, and caring even less about my own concerns – is something that has doubled or tripled, and maybe that's because I did have an iota of being open to other people when I was younger and always feared that I wasn't open enough. Maybe that was enough to be as fully open as I wanted to be later.

<center>❁ ❋ ❀</center>

Dusk Weaver *was born in 1952 in Daytona Beach, Florida. His mother's name was Ella Mae and his father's was Oder Tindle Weaver. His children's names are Forest, Robin, and Wendy. He currently directs a 4-H children's music program (Junior Appalachian Musicians) funded by North Carolina Council for the Arts; he teaches guitar, singing, and other private music classes; he performs live music, both as a soloist and with accompaniment; he is an award winning songwriter, recording artist, poet, and non-fiction author; and he copy-edits, ghost writes, edits, and writes for corporations and individuals. He enjoys living in an intentional community, bodysurfing, homesteading, playing and spectating volleyball, repairing and customizing stereo gear, sharing and listening to troubadour music, applying sacred geometry in various design work,*

watching inspirational movies, and doing acoustic treatments for music rooms.

Taped interview with written edits and additions. December 23, 2012.

I am tempted to jump ship now and change what I was going to talk about, because I'm inclined to choose the '60s social movement and its explosion of freethinking, of people questioning authority, of controversy over the Vietnam War, and of so much more. I'm tempted to go with that, but it would be a fairly obvious choice, and anyone else from my era is likely to choose that "turning point" as well.

Instead, I'll stick with my initial thought involving a more personal milestone: the seemingly innocuous decision I made in my freshman year at Furman University (a liberal arts college) to knock out some of the required humanities courses instead of barreling ahead with the many hard science courses I planned to pursue. You see, I anticipated majoring in chemistry, and I supposed that, as an adult, I would basically be an egghead type who would work as a chemical engineer or maybe as a pharmacist, but, in any case, an egghead type who saw science as both the question and answer to whatever issue would come up.

However, for spring semester of my freshman year, I signed up for two required humanities courses, primarily so that I

could get them over and done with early in the going. Within a short time, that seemingly unimportant decision began to stand me on my head, as it were. When I'd signed up for the two required courses, I regarded them as something of a nuisance standing in the way of my *real* education, but within a few weeks of class, I began to awaken to the whole new world of the humanities. For the first time in my life, here were intriguing considerations of what it means to be human, of ethics and civilization, of individuality and society, of means and ends, and of a thousand other topics my sheltered life had theretofore never touched upon.

Especially important in these studies were the ideas distinguishing spiritual matters from strictly religious ones. It may sound incredibly naïve of me in this new millennium of ours – in this current world of East meets West, of instantaneous global communications, of affordable and swift world travel, of Internet access to any culture on the planet – but when I enrolled in college on academic scholarship as Valedictorian of my high school class, as Star Student, as Best Student-Electronics, as Most Likely to Succeed, and as whatever else I have long since forgotten would commend me to that world of higher study… I say, when I enrolled at Furman, the limits of my inquiry into matters of the soul were found in the two Westminster catechisms, in Presbyteria USA, in Hartness-Thornwell Memorial Presbyterian Church, and in

the fundamentalist preachings of one Dr. M. A. MacDonald. Although I could have handily delivered an impressive series of lectures on predetermination, although I could also have stood clutching a closed church hymnal while singing 100 of its entries start to finish, I nonetheless had never even read or heard words such as "gnostic" or "reincarnation."

My personal world expanded in proportion to the multitude of new ideas, but this expansion from religious faith to spiritual seeking turned both my old and new worlds upside down. That is to say, I didn't merely add spiritual considerations alongside those of my Presbyterian upbringing and of the material world around me; I resonated so powerfully with the broader, spiritual thought that I quickly came to value it *above* the other considerations. Within the first week of the two classes, I had already shifted my entire perspective of life, looking more at the human side of things, at sociological implications, at feelings and humanitarian questions. Then, within a few weeks more, I began to actually prioritize the spiritual aspects of any given consideration.

In a short period of time, perhaps even during the spring semester itself, I dropped my plans to seek a career in chemistry.

Throughout grade school and up to that fateful semester, my life and its focus had been on math, science, career building, material success, seeking approval from others, adapting

myself to match what I thought was expected of me (even if the adaptation felt inappropriate), and above all else, making certain not to rock anyone else's boat. In other words, I had adopted a set of values that said: Stick to the scientific facts, study and work hard, rely on others' ratings of you, conform, don't make waves, and rise to the top. My guess is that millions of my contemporaries took on those values in youth, but that a large percentage of them experienced epiphanies similar to my own whenever they encountered cultural, philosophical, political and/or spiritual crossroads, either in college or in the general school of life.

So it was that everyone among my family, high school friends, and local community were astounded when I underwent so dramatic a conversion less than a year following high school graduation. They had seen me as the guy who'd advance mankind by way of this or that patent, and I can't fault them for this, because it is precisely how I had fancied myself in the future. Even my SAT scores had concurred with this forecast, for I'd stood out in mathematics far more than in verbal skills.

I trust that what I actually did with the subsequent years merits my good fortune in having been figuratively stood on my head. I don't have the first patent to my name, but I derive great joy in having copyrighted my personal account of life in an intentional, broad-based spiritual community of 350 men,

women, and children. (As of this writing, I've lived in such intentional community for 36 years.) I've no new chemical formulations credited to me, of course, but I am thrilled instead that polycarbonate replicates (CDs) of my music albums continue to inspire and encourage others in their lives. Obviously, I gained no corporate title to indicate success, either in pharmaceuticals or in any other chemical industry, but I gladly served as head of the Percheron draft horse program on Tajiguas Ranch in southern California, rearing and training those gentle giants to plow, harrow, plant, and cultivate organic vegetables for market to all 50 states of our country. I haven't rocked the world with some drug breakthrough to better treat a dreaded childhood disease, but my spirit spills over from sharing the delights of mountain heritage music with Appalachian youngsters and of Americana music with other children by way of their private lessons. I was not directed to attend (or to give) scores of business seminars on various subjects, although my new life does allow me to share hundreds of live music performances in which the matters of heart and soul are highlighted. I was not stationed and transferred from one great city to another in the course of climbing some corporate ladder, mind you; rather I've found idyllic fulfillment in creating a homestead life with my beloved Caroline, where we've handcrafted two unique eco-homes and where we raise goats, chickens, bees, gardens, and orchards, all

of this synchronized with, and supportive of, the precious spiritual priorities that she and I individually embrace.

It is with tremendous gratitude that I acknowledge the time of grace bestowed upon me – the freshman spring semester of study at Furman – when the remainder of my life was so swiftly rearranged for the better. To refer to that time of grace as a "turning point" seems inadequate to cover all the blessings I received as a result of it… it was more akin to a pivot point… no, no, let me describe it as an axial shift.

Just now, I am reminded of a particular, sunny afternoon in the fields of organic row crops of Tajiguas Ranch in California. I remember that, after hours of cultivating vast stands of corn, peppers, and artichokes (with the powerful Percheron stallion named Jake having provided horsepower for the tasks), I paused in the work a while to soak up the lovely scene along with a bit of warm, California sun. After a few moments in this reverie, I became bemused and chuckled to myself and to Jake, saying, "Jake, ol' boy, I suppose this means I've lived up to that Most Likely to Succeed superlative, huh?"

Jake simply neighed and shook his head in agreement. Then we got back to the work at hand.

Kate Long *was born in 1946, right at the end of World War II in Oak Hill, West Virginia. She has been a grade school teacher, a counselor for runaway teenagers, a supervisor of special education, a bartender, a waitress, a writer, a newspaper writing coach, a performing songwriter, and a reporter. She has also worked with families who have handicapped babies. She is currently working for* The Charleston Gazette. *She writes very complicated stories about healthcare, and she tries to put them in plain storytelling language so that people can get a grip on them. She wants to spend a lot more time with art and music. She has a long list of things she would like to explore with the time she has left.*

Taped interview. December 29, 2012.

When I was a teenager, I drew all the time, and I painted, and I did all kinds of things like that, and when I went to West Virginia University, I was an art major, but they didn't have any kind of art department then. I ran through all their courses and got bored and switched majors. I switched over to English, which prepared me to do nothing, but I read a lot, and partied a lot. I wish I had found a way to continue to do art.

I have done a lot of things that I think I've done in a way that's helped people in the world, but for myself, as I look back, I think it's very important to be happy and to do the thing that you just naturally do, that you feel that you were created to do.

If you're an artist, a lot of times, you tell yourself, "Well, I'll get this job here. I'll teach second grade. Or I'll teach whatever, and I'll do my art outside that." You can point to a few people who are able to do that, but most people can't. Really, in my experience, being an artist requires concentration. It requires time, and it requires a level of availability to the creative spirit that isn't possible when you have to be thinking about chronic disease, or mortgages, or whatever is occupying my mind.

That's not to say that those things aren't valuable and that I'm not glad I did them. I just think, you know, when you look at the scope of life, we're just here for a short period of time. Why are we here? Who knows? What are we? Who knows? But it does seem clear that life is like a game that you learn how to play, and the goal is to be happy and to not hurt people. Maybe help people.

My dad was a workaholic, so I think I kind of took after him. So, when I think about times that I was unhappy, my mind immediately goes to times when I was trying to accomplish some huge project that was just way too big for me. I was like a raccoon trying to birth an elephant. This project in the last year has been like that. I have spent many late nights with papers all over my house, trying to pull all these facts and figures together into some kind of readable, coherent form.

I think also of the time that I was writing a book called *Johnny's Such a Bright Boy. What a Shame He's Retarded*, which

was about the way low-income and minority children are classified "retarded" in the schools. It was an important book to write, and I had, in my twenties then, the same philosophy, which was, if it will do good, and I can do it, then I should do it. In that case, specifically, "If I put it into a story and into words that people can understand, then maybe it will help stop this labeling of children," and, of course, it didn't.

I've had this enormous urge to save the world. Maybe it's not ridiculous. I don't know. At the time, I always thought it was worth it, and yes, that book did a lot of good. Yes, it became a textbook. It sold tens of thousands of copies. I still run into people who used it. It probably helped a lot of kids. Now, was this what I was supposed to do in life? I don't know. The main problem was not the book. It was that I was not happy while I did it. I went at it very intensely, the raccoon birthing the elephant.

There's a sign on my wall over here hidden behind that teddy bear that says, "Just because you're saving the world doesn't mean you have to have a bad time." I'd like to think that's true. Maybe what I need to learn is how to do good things and still have fun, and not get myself into these pickles where I have to work, work, work in order to produce what I committed to do. I better learn that skill fast. I've got less time now, and I want to enjoy it a whole lot.

As soon as I finish this project, this series on chronic disease and child obesity, I'm going to clean my house, and get all those papers out of there. I'll be able to invite people over to dinner again, and maybe have little house concerts in my house, and do all the things I can't do now because my project has taken over my life. My work has taken over my life too many times. Don't let that happen. That's my advice to myself. If it's useful advice for other people, that's good.

Randall Roberts *was born in 1951 in Covington, Kentucky. He is a college professor at Berea College. After he graduated from college, he was a high school English teacher for five years. Then he took some long adventures before returning and teaching high school for a few more years. He went to graduate school so that he could teach English at the college level. He taught at Eastern Kentucky University for ten years and has taught at Berea for 13 years. He enjoys outdoor adventures: hiking, backpacking, climbing, cycling, walking, and running. He lives out in the country and he likes to cut firewood, garden, and do other chores around his home. He is a people-person when he is around people, but he thinks people see him as a solo person, or a hermit. He likes to hang out by himself in the country where there's not much conversation and chatter.*

Taped interview. January 17, 2013.

I was raised in a close-knit, small family and I think that I was the one in the family that "got away" – kind of using a Barbara Kingsolver term from *The Bean Trees*. I didn't get away until I was in my middle-twenties, and I guess when I look back at my college days, which were also still part of the Vietnam War and the wars in southeast Asia – and I surely did not want to be part of that in any way, didn't believe in that – but I wish that when I was a college student, that there would've been some way that I could've been the one to get away at that time. Maybe to travel abroad, maybe to go further away from home to go to college, maybe been able to take some big adventures in those years, but I really didn't have the confidence in myself, nor did I really have the financial means, or the real awareness. Becoming aware of the Vietnam War when I was a senior in high school and in early college was a real eye-opener for me, what was going on in Southeast Asia. I saw some friends from church, saw their bodies returning, and I talked to a priest at the Episcopal church and realized that there were other ways to, so to speak, serve your country, besides being in the military, and that there were a lot of things going that I really had no idea about when I was a high school student, which is very unfortunate. So, I guess, maybe if I could have gotten away

from northern Kentucky around 1970 or 1971, something like that.

After I made my first trip to the Rocky Mountains to go backpacking, which really would have been 1975, I guess the thought kept going through my mind, "My goodness! Why haven't I been out here before now?"

How do you think that would have changed you as a person at that point in your life to have travelled and been able to do some of those things?

Well, I think it would have taken me away from that trap that so many of us fall into with consumerism, and capitalism, and material possessions. I worked hard when I was in college. I started at a community college and worked hard in the academics, but also worked hard with part-time jobs to pay bills, to pay for a vehicle, to pay for insurance. You know – falling in and out of love a couple times, which in some ways was good and in some ways was wasted time and energy. Maybe I wish that I wouldn't have been, what I call, in that trap, or that typical young American that grows up with not a whole lot of awareness, not a whole lot of money, and you work hard and you make money. I probably should have used my money in a better way.

I remember applying to Berea College out of high school, and I wish I could have been accepted to Berea College. I think that would have created some opportunities for me that I have mentioned already in this interview. I think it would have maybe put me on the path that I'm on for the last 30 years. Who knows?

I didn't find the love of my life until 1981, and maybe that's something I wish could've happened earlier in my life. Things would have been different.

Do you want to tell me about something that did happen during that time that has shaped who you are?

Well, I think college professors opened my eyes and also opened my heart to helping me have some pride in my mother's family being from Appalachia. That's something I never really embraced growing up. I remember a professor in a sociology/anthropology course who really introduced me to the situation of American Indians, or what I like to refer to, like the Canadians, the "first peoples". I really had no awareness of that. I had another college professor who really opened my eyes to the situation of African Americans in this country and the Civil Rights movement. I had no awareness of that at all when I was a high school student.

Actually, when I was a graduate student in 1988, I was aware that the county that I grew up in, Boone County, was the location of Toni Morrison's novel *Beloved*, and I had no idea that there were runaway slaves going through northern Kentucky and crossing the Ohio River.

I think some things were brought to my attention as a college student, and in that one particular instance not until I was a graduate student, that I wish I would have been aware of when I was younger, but when I did become aware of it, it motivated me to study and to learn more about those situations and to be involved with those situations in my adult life.

Life is good these days. Looking forward to retirement in three years, maybe. It's been a good experience teaching at Berea and living out in the country outside of Berea, and I guess you could say that I have a satisfied mind these days.

Fred de Rosset *was born in 1951 in Ellwood City, Pennsylvania, near Pittsburgh. He teaches Spanish, general studies, and humanities. He is interested in reading, working outdoors, spending time with his wife and daughter, talking with his friends and students, and walking his dog. He says he has always been a very restless person. He has a very portable identity and*

sense of place. Because he was brought up as a missionary child, which is very much like being a military child, he always tends to be looking at the world from the outside in, because he has had to move from place to place so much. He has never been quite at ease when people talk about community.
Taped interview. January 24, 2013.

 I think it's not what I would have done differently, in retrospect, I suppose, because what happened was more an event which marked me for life, though at the time, it was extremely unpleasant, and at the time, I probably would have changed it. The further removed I've gotten from it, the more I've realized how important that was and how it has shaped and made me into the person that I am, and gave me strengths that I never would have expected.
 I grew up in Peru, on the northern coast of Peru in a city called Trujillo, because my parents were missionaries, and they ended up spending close to 44 years of their lives there, really a lifetime. As a consequence, all of the children – four children – spent significant portions of their childhood there. Most of us came back to the United States when we were 13 or 14. As part of my childhood, schooling was obviously an issue. They could have sent us to national schools, but they chose not to, partly because they wanted us to eventually integrate into American schools and go on to college and university life.

When I was 9, I was sent off to a school in the jungle – in the upper Amazon in Peru – and spent 3 months there, and during the course of that time, became very, very ill. So ill, in fact, that my condition was critical. When I was returned to be with my parents 3 months later, they picked me up. I was barely alive. After visiting some doctors and what not, it was determined that I had tuberculosis. That, of course, was not initially a very happy diagnosis, one might say. What ensued was that for the next year, approximately 9 months to a year of my life, I would spend largely in isolation, in bed for the most part, recovering and regaining my strength. While chronologically, you can measure that in days and months, every day seemed for the initial period of time like an eternity, because here you are, by yourself, faced with yet another day to fill, with what? With things that you have to invent, or imagine, or learn to deal with.

While it was a terrible, terrible hardship initially, partly because really the only people who visited, other than the occasional friend of the family – you know, my parents would come and go, but other than that, it would be doctors. The doctors would be coming, and I would have injections administered three times a day. So, even visitors were not entirely a happy prospect.

What I subsequently learned was so valuable about the experience was that I learned to deal with silence. I learned to deal with myself. I learned to come to terms with some

important things about living, and that is that when you are faced with such circumstances, you have to rely on your own resourcefulness. You have to rely on your imagination. You have to learn how to cope and deal with – ultimately with silence, which seems to be, in modernity, people's worst enemy. People seem to constantly be filling their silence with electronic stimulation or activity – one thing or another – because of what they might encounter in silence. And my own belief, I guess, is that in silence, we probably learn the most important lessons about ourselves. If you do believe in a god, I think probably that is the most likely place you will encounter God.

From the contemplative tradition, we know that silence is a very important part of that, and if one were to return to the Book of Psalms in the Old Testament from the Judeo-Hebraic tradition, David is constantly reminding the people to "be still and know thy God".

Though it is a very painful and trying experience, once one overcomes the noise of one's own demons, one discovers a great deal of peace and tranquility beyond that and a whole new understanding of life and of oneself, and of God – I think – that, otherwise, cannot be gained.

Moreover, during that period of time, I learned to knit, I learned to play chess, I learned to read, I learned to love words. I read the dictionary and I discovered how words help define

one's silence and one's world. It's no coincidence that, again, within the Judeo-Hebraic tradition, the first gift that God gives to Adam is to name his world, and it seems to me that that's one way of learning – or beginning to possess the world around us, and it's the initial step in terms of understanding what is around us, because words are the window through which we begin first to peer into others and those things about us, in many, many ways.

If you just think about a person who you see, and how your experience of them begins to change as you learn their name, and then you learn to identify things about them, and those words begin to lead you further, and further, and further into the reality that constitutes who they are – and words began to reveal great things and helped me understand a great number of things about the world, so they became very important, but they became even more important because they were framed in silence, and I was able to hear each one of them, in a sense, whereas now, we fill the world with words. We fill our silences with words, and we don't really hear any of them. The silence helped me hear them, and helped me understand them, and helped me better to define the world in which I was living, and in which I would live.

So, the year was a long and painful year. I was separated from other children. I wasn't out running about and playing soccer and doing things that a child would do, yet the further I

became removed from that experience, the more I began to realize that I had gained an enormous strength and a dimension that so many others lacked because I had been denied that activity, and because I had been forced to go somewhere that most people would choose not to go.

As life has progressed, I find that it is very, very difficult, for example, for me to be bored, because there are so many things that are alive in my mind. There are so many things to think about. I don't depend on technology and electronic stimulation and outside things to keep me interested. In fact, oddly enough, I find that if I do experience some boredom, it tends to be more frequently when I am with people who wish to waste time, or who wish to fill silences with either empty rhetoric or activities which seem to mean very little.

In any event, it's one of those great paradoxes, that what can be viewed as a terrible, terrible misfortune, and a handicap, in fact turns out to be an enormous gift and a great blessing that has lifelong lessons to harvest. It keeps teaching you as you move further through life. And that certainly has been the case because here I am over 50 years removed from that experience, and yet, I still, on a daily basis, continue to be blessed by what I gained through the sacrifices that were forced upon me during that period of time.

I think, probably, like so many important lessons, I think there was some anger, there was some bitterness, there was

some disappointment, there was a sense of unfairness. "Why did this happen to me?" But, I think as I steadily moved away from it, I began realizing how it had altered me, how it had reshaped me, and what it had given me.

I think that's so frequently the case. At least, that's been the case in my life, where even some of my greatest teachers – at the moment, I may have been a little resentful of them because they pressured me so much, but little did I realize that they were doing that because they respected me and they demanded something of me. Years later, I realized that that person was, in fact, doing me a great service by forcing me, sometimes kicking and screaming, to go places where I would otherwise not have gone. This lesson that happened as a consequence of an illness taught me things which, in many ways, were very, very similar to what my greatest teachers taught me, and in a similar way, in that the further removed I have become from them, the more grateful I am to them, because of what they did for me.

I think so often people think life is unfair, and life is not fair. I mean, we cannot ask from life what it cannot give. That is, we all have been blessed and we all have suffered misfortunes, but I think that everything in life, no matter how awful it may be and terrible it may seem, can be recycled and redeemed, to help us at some future time, and not only to help us, but because we have been the ones who have had to endure it, or

go through it, it in turn can help others to bear the misfortunes and grief of life in a more useful and beneficial way.

❀ ❁ ❀

Tripp Bratton *was born in 1962 in Washington D.C. He is a professional musician and music educator. He is a teacher, performer, composer, and arranger of music. He is interested in the arts and in using the arts to build community. He believes it is important to bring the arts and social public life closer – to break down barriers between audience and performer. He is also interested in science, philosophy, and spiritual exploration. He paints, draws, and does digital art. He has recently licensed a number of his recordings to a company to use for video and film. Almost everything he does is related in some way to music or the arts.*

Taped interview. February 6, 2013.

When I was a kid, around eleven to fourteen/fifteen, there were two main events that happened around me that really changed – I didn't realize how much at the time, but that really changed my trajectory and what I ended up doing with my life. When I was a little kid, I was really fast, and I was into athletics. I was always coordinated. You know, my eye/hand coordination was really good, my reflexes were really good. I

was one of the fastest little kids, you know? Stuff like that. I played football, soccer, basketball, and all this kind of stuff. I eventually ended up taking to soccer more as I got a little bit older. And this is still pretty young. Pre-teenage.

When I was eleven – well, ten and eleven – two main things happened. One is my parents got divorced and I moved quite a bit. I'd already moved a couple times in school, going from school to school and all that kind of stuff, before that, but then every year for about three years I was at a different place. I had to make new friends, and I had to do all these things.

Also when I was eleven, I was a big tree-climber. I had tree forts and stuff, and back in those days here in Lexington, there was still a lot of development happening, even closer into town, and then in my neighborhood, there was this whole forest area, and I'd go in there and build tree forts with some of my friends, and all this kind of stuff.

I decided to climb a big tree, and I fell out of it, and I broke my leg in four places, and it put me out for a whole summer, and I never quite recovered from that, as far as my athletic ability. I mean, I still was able to do soccer, and all that kind of stuff, but during that period I started getting more into music. I started playing trumpet, actually. I played trumpet, and that led to other instruments.

That was kind of the end of me being, like, "sport kid". I started getting more into art and music, and then, because I

was constantly moving, I was having to make new friends and all this kind of stuff, so I became a little bit socially awkward. Everywhere I moved, people already had their cliques and friends and stuff, and so I was always a little socially awkward during that period, and I found that music and art helped me to express myself and to kind of find a voice for myself, and all that kind of stuff. And identity. Things like that.

Eventually, by the time I was in seventh grade, I was at another new school, and I started getting in with the wrong crowd a little bit. I had actually broken my trumpet, [*laughs*] and I wasn't able to play trumpet. I was kind of lost because of all the – I just didn't know these people, and it was just like, "I have to do this again, meet all these new people." Then there was this little crew that kind of adopted me a little bit, but I was like, "These folks are kind of trouble," or whatever.

I went to a band concert, an assembly at the school, the middle school I was at, and they had this great drummer. And, just the way he played – because of my athletic background, I always thought it would be fun to do dance, and stuff like that, but socially, I was like, "Where would I go dance?" You know? As a twelve – fourteen-year-old, whatever – but when I saw this drummer, it was like, "Yeah, he's athletic and sporty, but it's also very graceful, like dance," and stuff like that.

That's what started me into drumming. I was like, "I'm gonna join – I'm gonna do drums. I'm gonna get back in the

band," because I had dropped out when I messed up my trumpet.

That period is what led to me ending up getting on the drums, because drumming fit in with my physical skills that I'd already had from doing sports so much, the reflexes and the coordination, things like that, and I was able to pick it up really quick. My mom, being a musician and all – I already had a lot of music in my ear, and stuff like that, and I always liked music, and I listened to radio a lot in those days.

Going through that and drumming and stuff, it helped me find a place. Getting back in the band, I made new friends. That led to a lot of other stuff. I didn't really realize at the time that was gonna end up being my main thrust in my career, or whatever, being a percussionist musician, but I found that I excelled and I became leader of the percussion section within the first year I was in the band, and so, "I'm doing pretty good on this," and I liked to practice it. It's a lot like drawing or whatever. You just sit down and focus on something for a while, and then you get better at it.

I think that because I had my sort of social world kind of ripped apart every couple years or whatever, and because I was kind of that – my physical change of, you know, having to go a whole summer without doing sports, and even after that, I never quite felt quite as – my leg always kind of hurt for a while, even still.

I think it altered where I was headed. If I hadn't started drumming then, I probably wouldn't have started drumming. I probably would have gone into something else altogether. Maybe art. I thought about doing commercial art up until, like, my senior year of high school. Doing like commercial art or illustration. That's what my cousin does. My cousin has a design company, Edmon Design. Now it's called something else. Anyway, it helped me kind of through that period, you know, getting into music. Hopefully that's kind of along the lines of what you're asking about.

Drumming for me has become kind of a – well, at first, it was just a skill I wanted to try to attain. I just wanted to be able to play as good as I could play. Whatever I wanted to try to learn, I wanted to work it out and try to learn it and be the best at whatever I did. I did marching band, where you have all the fancy little rudiments and things. I did drum corps, which is like the high level – the highest level of marching band, and the drumming in that is at the most difficult level for that.

For me, it was about pushing my limits, seeing what I could physically accomplish. It was still that kind of athletic mindset, in a way. It was like, "I'm gonna be the best, strongest, fastest, loudest," you know, with musical constraints.

Then, as I got into it a little further, I was fortunate to – and this is kind of another event that was a big trajectory-changer while I was in college. It was kind of a fluke event. There was

this modern concert – modern music festival concert thing, and this dancer was doing a duet piece with a trumpet player. The trumpet player, oddly enough, that very same day, got bit – or got stung on the lip by a bee [*laughs*], and this was just that day – just right before the performance. The guy who was producing the performance got me out of the audience – I was just dressed in street clothes – and said, "Why don't you do an improv with this dancer?" I got a couple other percussion friends of mine who were in the audience and said – we went backstage and found – there was this green room and there was a bunch of instruments there. We just took a bunch of instruments out there and we did this percussion improv with this dancer and it really was just one of these things that just – wow – just a magical kind of like – just amazing.

I ended up talking with the dancer afterwards and we started a long friendship, until she – you know, we're still friends, but she moved about ten years ago out of the area. She started another company. I got involved with her and her dance company and her partner, who – her name was Meriah Kruse. The dancer I worked with was Katherine Kramer. Meriah Kruse was her partner. They were just starting a company called Syncopated Inc., and they wanted me to come in and play percussion for their classes, and so I started doing that and Meriah and I started – you know, we became really

good friends. Kathy, too, but Meriah in particular because of, you know, this particular thing I'm heading towards.

We decided to start an African music and dance program. She had been going every summer to this retreat on the coast somewhere. I forget which Carolina it was in, but she'd go and she'd get some African dance lessons, and then she would teach parts of it.

We decided to start a grant-writing project, and we wrote grants, and every year, we would bring an African, or Brazilian, or South American, or some type of drumming dance expert, and then bring them over, and have them do a residency with us.

I really started becoming exposed to really high quality hand-drumming. I mean, I had been doing little congas and things like that. I had done some Latin percussion studies while I was in college. Just your kind of basic *bom bom bap*. Your basic Latin beats and stuff like that, that were common in jazz. I was in the jazz band, played some congas. Seeing the Africans talk about their culture and the way they would bring the dance and the drumming together, and the improv with the very high level of expression, high level of technical difficulty, and a high level of excitement or whatever, you know? It really struck me – it fit in with what I like.

As I got further and further into it, I started developing an appreciation for the drum as a kind of archetypal musical

instrument. There are several archetypal instruments, but drum is probably the key – the first one. Everywhere you go in the world, there's somebody playing the drum of some sort. Some kind of hand drum, stick drum, whatever. I found that even with people that I couldn't speak with, I could play drums with, and share, and learn and things like that. I developed an appreciation for the drum – the drum as a unifying thing, something that could bring people together. Rhythm – it's used to create social events, like dances and events, funerals, weddings, birthdays, et cetera. The drum has been part of that.

I started getting more and more into the idea of drumming as a way integrating with social and public life. I was fortunate to be able to go to Ghana a couple years back. Four years, I guess, now. Being able to see it in person where you go to an event, and just there's people there making music, drumming, dancing, whatever. Whether it's a soccer event, you're just visiting, you know, a group like a Berea College group visiting a village, they bring out some dancers and drummers to welcome you, and stuff like that. When they have their community – what we would call Town Hall – or their community gatherings or whatever, there would be drumming to start it off, and there would be some dancing, and then certain rituals that they would do – certain things that would be a regular part of what they would do, whether it was a social event, or a spiritual event, or a sporting event, whatever.

I would say that drumming has led me to an appreciation for community art-making and music-making and integrating. You go up here and you go to a music school, and you get this idea of like, "Oh, we play on a stage and the people in the audience sit there quietly and listen and they clap at the end," and all that kind of stuff [*laughs*], which is fine, but you go to places like Africa and most folk cultures, where it's just part of everyday life. There's nothing wrong with special occasions, going to see the Philharmonic, or going see the opera, but it is a different way that interacts with the public, and the public can get into it. They have an entry to participate with it, as opposed to just watching and clapping at the end. They can dance, or they can sing along, or whatever.

It opened my eyes to that aspect of music, because the drum is so universal and used in all these different ways, that it really kind of helped shape – 'cause that wasn't my intent. My intent drumming was just to be the best drummer, and be the best performer and play, and be able to play anything I wanted to play, but then through my cultural experiences, I started becoming more – and it also kind of went hand in hand with my spiritual or my philosophical thought processes at the time. And continuing.

That's probably the biggest surprise. I've done a lot of things, but that's the path that has opened before me the most often. And it's why I still like to teach kids, too. I like to go and do

those little kid programs, and stuff like that, because I like for people to just think of music as something that everybody does, and not just something that, "Oh, I'm going to be in the band, or else I don't play anything." You know? I like the idea of getting kids just to where they can play drums, and they can always play drums, because once you can play a drum, once you can play some rhythms, you'll always be able to do that. If you start some kids off doing it, even if they don't end up in band, they still will have a sense of rhythm and can play some basic beats and some things like that, and can get some people together to jam, whatever.

I'm into the idea of giving – or assisting people to find rhythms and music so they can play further throughout their life, regardless. This school here at Berea – I don't have a lot of music majors, so most of the people that I teach are not going to be professional drummers or musicians, or whatever, but they will have kids someday, or most – a lot of them, and they will be in situations where, if they have some rhythms that they can play, some basic skills on the djembe or on a hand drum or a conga or whatever, they can get together friends and play and keep music as a part of their life as they keep going.

That's part of what I've developed into as a concept for the way I think about my career as a percussionist, starting off as just me trying to be the best percussionist, and eventually getting to a point to where it's become something of a way of

spreading a sense of togetherness through music participation, and through spreading it to the next generation, sharing the joy of just making music. I've moved into that direction through the circumstances or through the things that have happened to me over that period, and on.

The great thing for me about doing percussion and music is that it keeps me fit, to some degree [*laughs*], or at least it keeps me agile. It's been great for having friends and being social because I've got a lot of friends that I get to play with in different situations, and all this kind of stuff. That was one of my early reasons for getting into music, was to help make friends, and because I was kind of socially awkward. It's been really good for that. Percussion is great because you can play with all styles of music. You can play melodic, you can play hard core drum set, you can play hand drum. It's good for somebody like me who wants to keep trying new things and doing different things all the time. I can still be in the world of percussion and just go from playing African drums, to drum set, to vibes to – I'm doing a Bollywood show this week, and I'm doing a marching band show after that [*laughs*] and I play with folk groups.

Percussion has been a good fit for me, for that reason, too, because it's so diverse. If I'd stuck with trumpet, I'd probably do mostly just like – just jazz. Or just orchestral.

It's been good, and music is a broad enough field that between performances, and teaching, and composing, and things like that, I can keep enough income coming in and still have a bit of – not as much as I have thought, but a little bit of autonomy, although I have a lot of commitments [*laughs*] and not as much autonomy as might seem. It's not like I can just like, "Oh, I'm gonna take a break this week." I can't really do that, but I do have quite a bit of flexibility, and I can decide for or against doing a certain project, so it's kind of nice. I have certain times when I'm super busy, and other times when I just have some open space and stuff like that.

So, it's kind of nice for me, because I don't like repetition, which is odd for a drummer who plays repeating beats, but I don't like to do the same thing every day or every week.

Some folks I know were in a gig and they were playing just with one band and they played the same show every weekend, and I've done that at times, sort of. You know, I've never been in just one band, but anyway, blah, blah, blah [*laughs*]. You'll have to cut half of that out, and all that, because I can ramble. You should hear my mom. You can't get her to stop, once she gets going.

*The **subject** of this interview was born in 1954 in Detroit. He is currently a college professor. He grew up in Florida, near the beach, surfing; he enjoys tennis, golf, hiking, and being outdoors – watching birds, animals, smelling the trees, fresh air. He reads a lot about Native American culture, American culture in general, history, explorers and explorations, natural history and earth sciences – weather, astronomy, the stars, birds, and mammals. His favorite activity is a good discussion of a good book with good friends. He likes listening to music, mostly the Blues, classic Rock-and-roll, and classical pieces. He loves thinking really hard about things. It doesn't matter so much what it is, as long as there's intensity. That's one thing he likes about sports and music. He is pretty competitive – he likes to hit things and keep score. He enjoys traveling. He is pretty low-key and quiet. He is fiercely independent. He doesn't take himself very seriously.*

Taped interview with written edits and additions. January 31, 2013.

What event most affected me and who I am and have become, I think, would be the Vietnam War, which was at its peak when I was a teenager in the '60s. The war was on TV news every night. It was a very unpopular war, and increasingly unpopular and ugly. Nightly TV coverage let me see bodies and body bags, death and destruction and human

suffering, every night in my living room at home. I stood a good chance of having to go to Nam, and so there was some self interest in paying attention, and then starting to oppose the war. It led me to ask questions about what obligations I have to my government and why, which turned out to be philosophical questions, but I had no idea at the time. My parents are not educated people: my mother finished high school and my dad dropped out after the 8th grade. They had no idea how to address my questions about political obligations. All that sparked, I think, my professional pursuits of questions in ethics and political philosophy and rights.

The war, as I witnessed it, also led me to appreciate intellectuals as in a position to lead, because in the '60s war protests took place on college campuses like Columbia and Cornell and Berkeley, where not only bright students, but bright faculty, were exercising their minds and raising these kinds of questions and actually mobilizing people to protest the war. I saw that and came to respect well-educated people in a number of ways. That was important because my parents were not educated peoples, and I was not around educated people. I never met a professor until I went to college.

To be frank, all this witnessing of the war and my responses coincided pretty nicely with being a rebellious teenager. My parents were politically very conservative, so my questioning of the war and patriotism blended with a typical teenager's

looking to challenge parents and assert independence. The war in Vietnam was probably the most significant thing in the world that explains some ways in which things played out in terms of my interests, and what I do for a living.

Can you think of any specific stories that affected you at that time? Maybe something specific you saw on the TV?

I recall some specific stories and images that affected me at the time. I watched on TV scenes shot during the '68 Tet Offensive, where newsmen and cameras were actually there, on the frontlines reporting while ducking behind walls, and people were screaming from being shot. These scenes were pretty powerful to me. The My Lai Massacre occurred in March of '68. The pictures of the bodies, the villagers, the slaughter of children, women, the elderly, their bodies all in a row where they fell. There are the now classic photos – of a naked young girl running in terror from a napalm attack, of an execution in the street of a suspected enemy supporter. Then, a little bit later, while in graduate school, I met and played tennis with a man, a lawyer, who had been in Vietnam. His wife was a friend of my mother. When he came home from Vietnam, they had terrible marital problems, because in her words, "He was a different person, and he's never been the same." They're divorced. I also met men in graduate school who were a little

older than I and had been in Vietnam, including a man who had been what they call a "tunnel rat." Like the character Elias in the Oliver Stone film, *Platoon*, I met men who, when troops would find Viet Cong bunker complexes in the jungles, would be the one to go down into these barely-big-enough places for you to crawl, with a weapon in their hand and take on whatever it is that they found. Their survival rates were dismal; they witnessed much that they wouldn't talk about at all.

Besides leading you to this career and this mindset, how else has it changed you or shaped you? Or how exactly did it lead you to who you are today?

Aside from things I've already mentioned, my witnessing of the war – on TV and through meeting veterans – affected my political views profoundly. It led me to hate nationalism, including in sports, like the Olympics, where we count medals by country and, as others do, chant "U.S.A.! U.S.A.!", and, as others do, feel superior as a country for winning gold. Nationalism is a dangerous idea that has led to much death and horror in the world. It made me very skeptical and increasingly distant from ideas of patriotism, of identifying with a group (whether a race or an ethnicity or a nation); it led me to think of moral principles as universal, not relative at all; it made me

suspicious of government and military might and unchecked power, even within the U.S.; it made we worry about our capacities for collective self-delusion. The Watergate scandal of the early '70s, of course, helped develop these attitudes. Watching the war and its unwinding in the '70s affirmed my disdain for imposing culture and ideas on others, which resonated too in my reading about native Americans and 19th century government squelching of their cultures – "can't speak your language," "we're going to cut your hair," "can't dance this way." I would say that all this led me to be concerned about the poor quality of political and ethical discourse in America and the fact that we don't do a better job of teaching people how to think and discuss well together, to wrestle with issues in intelligent ways. To this day, I work hard on those skills every day, in class with students and with colleagues. I do care very deeply about that – a deep passion for pursuing truths thoughtfully, properly, and well – truths about the world out there, about others, about ethical and political matters, too. In this culture we do not do this well, even thoughtlessly dismissing the very notion of truths at all (is there really any doubt that rape or genocide is morally wrong?). This resonates with how witnessing the war made me still today disgusted with the practice of politics in America. I can't stand political speeches and political news coverage; the way politicians and analysts talk about people's lives in Congress is just appalling

to me. People don't have healthcare in this country and too many in Congress vote based only to prevent the President's re-election. It just infuriates me, the level of thought and discourse; it's too much in terms of tactics and gamesmanship, rather than substance. I have a real distaste for that. People's lives are at stake and politicians play games. The stuff of politics is far too important for mere tactical thinking about power: people's lives are at stake.

Having said all this, I am bit troubled by the question and my responses. I don't believe that witnessing the war, Watergate, political assassinations, the civil rights movements, or, indeed, other things, made me into what I have become. I think those experiences resonated with features of me already present, with dispositions, tendencies, deep traits of my being. My experience of the war, then, fed into what was already there in me, triggered traits already in me, perhaps channeled those tendencies in certain specific ways, but those experiences did not really shape me into who I have become. I've always been direct, blunt, and impatient with gamesmanship; witnessing the war and politicians' gamesmanship did not make me that way, but became an expression of those basic traits. In that way, perhaps, witnessing the war and other experiences has contributed to my interests and identity today.

I really am not comfortable talking about myself like this. I actually spend little time thinking about myself, who I am, my

identity and how it came to be; the world out there is so much more interesting to me than me. It has been a bit of a novel journey of discovery participating in this project.

❀ ❄ ❀

Bob and **Carolyn Jones** *live in their home of thirty years. They have enjoyed their forested surroundings on the Dry Fork River south of Hendricks, WV. Both Bob and Carolyn have taught school in Tucker County for thirty years. They have two daughters and a grandson who have shared their enduring love of the country life.*
Submitted in written form.

I was 27, Bob 39, and Leanna, our oldest, just three months old when we came to Tucker County, West Virginia with teaching jobs. At that time, most of our teaching peers were either using the summer months to take classes towards earning a Master's Degree, and thus a higher salary, or they were taking summer jobs to supplement their income. After much discussion, we decided to do neither of those, but to instead take the summers off to spend time together as a family. We spent the summers swimming in the river, hiking in the woods, camping, building fires for marshmallows, catching lightning bugs, taking short vacations, and chasing waterfalls.

Because of that decision, we not only developed a strong family bond, but our girls, Leanna and Emily, grew up with a deep love of nature and a strong appreciation of the beautiful world around them. We may not have a lot of wonderful things, but we have a lot of wonderful memories. I don't regret that.

Kathryn Akural *was born in 1944 in Baltimore, Maryland. She teaches at Berea College. Her interests include teaching, reading, animals, gardening, and music. She went to Gettysburg College and Indiana University. She married a Turk and moved to Turkey for three years without knowing Turkish, but she learned it. She likes languages. She enjoys working with elementary age children. If she could design her ideal job, it would be to teach college students about reading, writing, and language in the afternoon, and teach a class of elementary students about the same things in the morning.*
Taped interview. February 1, 2013.

I wasn't quite sure how to answer your question, but the things that came to mind were all personal, not world events. At first, all of my memories had to do with things I was taught by my grandmother, but then I thought there was something I was taught by my brother when he was five years old that has

really influenced me. I discovered it when I was teaching at Berea, in one of my first years here, when a student named Vicky asked me why was I so kind and good with children. I had never thought about that – or that I was. I said, "Well, I babysat a lot," and so forth, but I thought, "That's not all there is." Then I remembered this story.

It was a hot Baltimore day in the afternoon, and I was in high school and my younger brother and sister, ages three and five, and I were closeted in the only air-conditioned room in the house. It was really, really hot. I don't know whether it was August or spring. I can't remember– but it was hot as the devil. The kids were supposed to be on the bed resting while I was doing a Home Economics project, using my mother's sewing machine to put button holes in my dress that I had made. Linda, who was three, got off the bed, and – little diapers and so forth – started running around the bed, and I said, "Linda, get back on the bed. You have to rest," so, she got back on the bed.

I was working on the button holes and not being very successful, and getting more and more frustrated. Linda got back off the bed again, and I said more sharply – I really do remember this – "Linda, get on that bed, or I'm going to spank you."

She got on the bed. Next thing I know, she was off the bed and running around again – that happened at least twice.

Finally, I turned around and slapped her little bottom, through her diapers, not very hard.

What happened, then, was my *brother* started to cry, and I said, indignantly, "And what's wrong with *you*?" He said, through his tears, "You didn't spank Linda because she was being bad. You spanked Linda because you were having trouble with your sewing."

I don't remember any more than that, but that episode has stayed with me, and I'm sure that it wouldn't have if it weren't significant—if it didn't explain how I see children, because I really do see children as teachers of things that matter. So, that's my story.

How old were you?

Probably fifteen. Possibly sixteen. I did a lot of babysitting, and there we were. I was like a second mother, because the children – my mother worked, and the children were nine and eleven years younger that I am.

That's an amazing story.

Well, it is, I think. Had Vicky – I still know her name – had Vicky not asked me that question, I wouldn't have thought about it, so that also exemplifies for me what I have come to

understand and believe, that we learn from each other, that others help us think, and that we really do need other people to help us think about things that matter, in different ways. In that case, she led me into my own thinking.

www.ingramcontent.com/pod-product-compliance
Lightning Source LLC
Chambersburg PA
CBHW021816170526
45157CB00007B/2610